Dürer

Albrecht Dürer was without doubt the greatest artist of the Northern Renaissance. Living in Nuremberg, half-way between the Netherlands and Italy, he found inspiration in the work of painters of both the major European artistic centres of his time. But rather than simply imitating what others were doing, Dürer was very much an innovator. He is, for example, the first artist who is known to have painted a self-portrait and to have done a landscape painting of a specific scene.

The range and versatility of Dürer's work is astonishing. His wood-cuts and engravings made him famous across Europe and he is still considered to be the greatest printmaker of all time. As an oil painter, Dürer was equally successful at religious and secular subjects, producing magnificent altarpieces and powerful portraits. His drawings and watercolours are impressive for their diversity of subject-matter and the varied media in which they were produced. Dürer was to have a major influence on the development of European art.

Although Dürer lived five centuries ago, we are fortunate that so much of his work survives. Dürer published over 350 woodcuts and engravings which appeared with his famous AD monogram. At least 60 of his oil paintings have survived, an approximate number since in a few cases art historians are divided over the attribution of a work. It is impossible to know how many oil paintings have been lost, but these 60 may well represent most of his major works. Dürer, after all, spent much of his time as a printmaker and often complained that working in oils was time-consuming and badly paid. Finally, there are a thousand of his drawings and watercolours. Dürer seems to have realized that future generations would be interested in what he had produced. He carefully saved these works on paper, sometimes inscribing them with his monogram, the year and even a few words of explanation about the subject-matter. These informal drawings, produced as studies for prints and paintings or else simply for personal pleasure, are highly revealing about Dürer's interests and techniques.

More of Dürer's writings survive than those of any other early Northern artist. In the diary he kept of his 1520–1 visit to the Netherlands, he records seeing the works of the early Flemish painters, meeting the leading artists of his day, sketching the philosopher Erasmus, worrying about Luther's fate, and attending the coronation of the Holy Roman Emperor. Dürer also enjoyed the pleasures of being a tourist and his intense curiosity about the marvels he encounters is evident in his diary. He writes about seeing the bones of an 18 foot-high giant from Antwerp who had 'done wondrous great feats' and describes a great bed in Brussels 'wherein 50 men can lie'. He later sets off in mid-winter in search of a beached whale in Zeeland, explaining that the people there were worried about 'the great stink, for it is so large that they say it could not be cut into pieces and the blubber boiled down in half a year.'

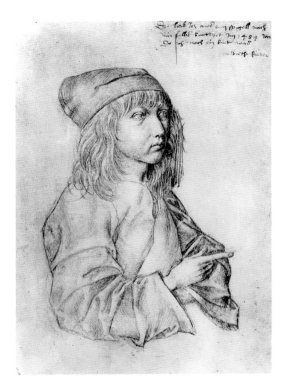

Fig. 1
Self-portrait at 13
1484. Silverpoint on
paper, 28 x 20 cm.
Graphische Sammlung
Albertina, Vienna

A different side of Dürer's character emerges from ten letters that he wrote in 1506 from Venice to his closest friend, Willibald Pirckheimer. This correspondence was discovered over two centuries later, hidden for safekeeping in a hollow wall of the Pirckheimers' family chapel. Dürer comes over as a warm and lively friend, with a wit that occasionally verged on the crude. He reports taking dancing lessons, at the age of 35: 'I went twice to the school, for which I had to pay the master a ducat. No one could get me to go there again. To learn dancing I should have had to pay all that I have earned and at the end I should have known nothing about it.' In another letter Dürer berates his friend Pirckheimer for chasing younger women: 'You ought to be ashamed of yourself, an old man like you pretending to be so good-looking. Courting pleases you in the same way that a big, shaggy dog plays with a little kitten.'

It is, however, the self-portraits of Dürer that give us the greatest insight into his character and beliefs. The first, drawn when he was just 13, depicts the soft features of a young boy, sketched with great confidence and skill (see Fig. 1). Dürer was rightly proud of his achievement and years later he added the inscription: 'This I drew, using a mirror; it is my own likeness, in the year 1484, when I was still a child.' Dürer's first painted self-portrait dates from 1493, when he was 22 (see Plate 4). In this work, quite possibly painted as a gift for his fiancée, his features are still youthful and he appears bashful. 'Things with me fare as ordained from above', the artist inscribed at the top of the picture.

Dürer's self-portrait of 1498, just five years later, reveals a transformation (see Plate 15). Dressed in elegant clothes, he stands up much straighter and is a highly confident young man. Beside him is a window, overlooking a distant Alpine landscape. The view is a pointed reminder that the well-travelled Dürer had recently returned from Venice, one of the leading centres of the Renaissance. His face is painted with great realism – evidence of his skill. Konrad Celtis, the humanist scholar and friend of Dürer's, once repeated a story based on an anecdote of the Roman writer Pliny, saying that Dürer's faithful dog had barked and wagged its tail when it first saw a newly-completed self-portrait of its master. This, perhaps, is the picture which had once so excited his dog.

The final painted self-portrait (see Plate 19), dated 1500, is inscribed: 'Thus I, Albrecht Dürer from Nuremburg, painted myself with indelible colours at the age of 28 years.' Although the artist has depicted himself in a Christ-like pose, this was no gesture of blasphemy. It was an acknowledgement that God had made Christ and Man in his own image. Artistic talent therefore ultimately derives from God. After this work, no other painted self-portraits survive, although he is known to have given one to the great Italian artist Raphael (1483–1520).

Dürer drew several self-portraits. These include an unusually frank one of him in the nude (see Fig. 2). A few years later he made a small sketch of his body with his hand touching a spot near his spleen (Kunsthalle, Bremen). In what may have been a note to a doctor, or perhaps a comment on his melancholic state, he added the inscription: 'I am pointing to it with my finger: that is where it hurts.' In 1522, towards the end of his life, he did an anguished drawing of *Christ as the Man of Sorrows* (formerly Kunsthalle, Bremen), giving Jesus his own facial features and depicting his own worn body.

Sometimes Dürer depicted himself in a painted altarpiece. On occasions he appears in his role as artist, proudly holding a board with his name and a few details about the work. At other times he gives a figure in an altarpiece his own features, such as the drummer who is mocking the afflicted Job or King Melchior in a Nativity scene (see Plates 26 and

DÜRER

DÜRER

Martin Bailey

Phaidon Press Limited
Regent's Wharf, All Saints Street, London N1 9PA

Phaidon Press Inc.
180 Varick Street, New York, NY 10014

www.phaidon.com

First published 1995
Reprinted 1998, 1999, 2001, 2002, 2003 (twice)
© 1995 Phaidon Press Limited

ISBN 0 7148 3334 7

A CIP catalogue record for this book is available from the
British Library

All rights reserved. No part of this publication may be reproduced,
stored in a retrieval system or transmitted in any form or by any
means, electronic, mechanical, photocopying, recording or otherwise,
without the written permission of Phaidon Press Limited.

Printed in Singapore

The publishers would like to thank all those museum authorities and
private owners who have kindly allowed works in their possession to
be reproduced. Particular acknowledgement is made for the following.
Plates 9 and 10 and Figs. 3, 11, 12, 14, 15, 20, 21, 22, 27, 28 and 34: by
permission of the Trustees of the British Museum; Plate 15:
Bridgeman Art Library, London/Museo Nacional del Prado, Madrid;
Plate 29: reproduction © 1994 Her Majesty the Queen.

Cover illustrations:
Front: *Self-portrait at 26*, 1498 (Plate 15)
Back: *A Young Hare*, 1502 (Plate 23)

27). But despite this abundance of different self-portraits, the three paintings which Dürer did when he was in his twenties most affect the way we view the artist. To us he seems eternally youthful, his curly locks of hair cascading over his shoulders.

Albrecht Dürer was born in Nuremberg on 21 May 1471, the son of a Hungarian goldsmith and the grandson of a peasant. The artist's father, Albrecht the Elder, came from the town of Gyula, in south-east Hungary, and had moved to Nuremberg in the early 1440s. He later went to the Netherlands for a number of years, presumably to continue his training, and on his return to Nuremberg in 1455 he entered the workshop of Hieronymus Holper. In 1467, at the age of 40, Albrecht the Elder married his master's 15 year-old daughter Barbara. Marriage enabled him to take Nuremberg citizenship and the following year he became a master goldsmith. The couple first lived in Winklerstrasse, in a house belonging to the respected lawyer Johannes Pirckheimer (whose son Willibald would later become Dürer's closest friend). In 1475 the Dürers moved to a larger house in Unter der Vesten, just beneath Nuremberg's imperial castle.

Albrecht the Elder and Barbara had 18 children, but only three survived into adulthood – Albrecht, Endres and Hans. The family must have had high hopes for young Albrecht, named after his father, and his talents emerged at an early age. Dürer later recorded in a short account of his family's history: 'My father took a special pleasure in me because he saw that I was diligent in striving to learn. So he sent me to school, and when I had learned to read and write he took me away from it, and taught me the goldsmith's craft. But when I could work neatly, my liking attracted me to painting rather than goldsmith's work.'

Dürer started in his father's workshop at the age of about 11. A goldsmith's training later provided a very useful foundation. It made him agile with his hands, taught him the skill of engraving, opened his eyes to the sculptural quality of crafted objects, and encouraged him to draw. But despite Albrecht the Elder's hopes that his eldest son would follow in his footsteps, the boy was determined to become an artist. He may well have been encouraged in this by his godfather Anton Koberger, the great Nuremberg publisher.

In November 1486, at the age of 15, Dürer was apprenticed to the painter Michael Wolgemut (1434/7–1519). Although Wolgemut would later be overshadowed by his talented pupil, he was then Nuremberg's leading artist. Wolgemut had married the widow of the painter Hans Pleydenwurff (active 1457–72), and he acquired Pleydenwurff's workshop in Unter der Vesten, just a few doors away from the Dürers. Wolgemut was a successful entrepreneur, handling a broad range of artistic work, such as painting altarpieces and portraits, designing stained glass and producing woodcut prints.

Dürer remained as an apprentice with Wolgemut for three years, learning the basic skills. The young trainee would have helped his master on paintings, by grinding the colours and preparing the wooden panels. He would have seen how stained glass was designed and produced. Among the woodcut projects in which Dürer was probably involved was the most important illustrated book produced in Europe during the fifteenth century, the *Chronicle of the World*. Koberger, Dürer's godfather, was the publisher and Wolgemut's workshop prepared the 1,800 woodcut illustrations.

A handful of drawings and watercolours of landscapes survive from Dürer's three years as an apprentice. The watercolour landscapes, probably dating from the summer of 1489, depict the surroundings of Nuremberg (see Plates 1 and 2). Dürer's first known oil painting is a portrait of his father, done in the early months of the following year, and

Fig. 2
Self-portrait in the Nude
*c*1505. Brush and ink heightened with white on green tinted paper, 29 x 15 cm.
Staatliche Kunstsammlung, Weimar

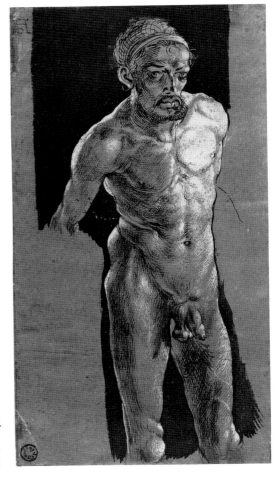

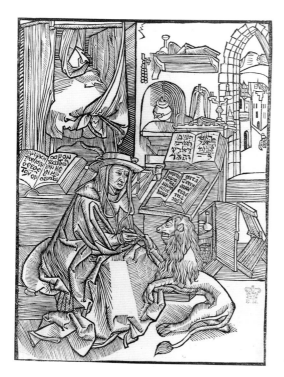

Fig. 3
St Jerome in his Study
1492. Woodcut, 19 x 13 cm.

Fig. 4
Female Nude
1493. Pen and ink on
paper, 27 x 15 cm.
Musée Bonnat, Bayonne

Fig. 5
Portrait of Agnes
Dürer
1494. Pen and ink on
paper, 16 x 10 cm.
Graphische Sammlung
Albertina, Vienna

it too is an astonishing achievement for a young painter (see Plate 3). This panel of Albrecht the Elder, probably along with a companion portrait of his wife Barbara, may well have been a parting gift just before the newly qualified apprentice set out on the next stage of his training.

In mid-April 1490 Dürer left Nuremberg to become a journeyman, travelling around Europe to work for different masters. These 'wander years' broadened his experience and introduced him to life beyond the confines of the family home and Nuremberg friends. It is likely that Dürer started by travelling down the River Main to Frankfurt. From there, he probably continued on the Rhine to Cologne, one of the greatest cities of medieval Europe. Stefan Lochner (active 1442–51), the finest of the early German painters, had died there and Dürer would have been keen to see his work.

Art historians have long debated whether Dürer went on to the Netherlands, as his father had done as a journeyman goldsmith. German painting was then strongly influenced by Flemish art, particularly the work of Jan van Eyck (active 1422–41) and Rogier van der Weyden (c1399–1464). Dürer's paintings show that he too was deeply affected by their work, which suggests a stay in the Netherlands. Yet it is curious that in the diary of his 1520–1 trip there is no hint of an earlier visit.

What is certain is that by the beginning of 1492 Dürer was in Colmar, in Alsace, where he had hoped to meet Martin Schongauer (active 1465–91), the painter and master engraver. Unfortunately, Schongauer had died the previous year, although Dürer was welcomed by his brothers who had assisted him in his workshop. A few weeks later Dürer moved south to Basle, where he probably stayed for at least a year. The Swiss city had become one of Europe's most important printing centres and there the young Nuremberg artist found work designing woodcuts. Among his earliest identified prints is an illustration of *St Jerome in his Study* (Fig. 3), prepared for the title page of an edition of the saint's letters. Other books which Dürer is thought to have helped illustrate include Geoffrey de la Tour Landry's devotional text *Knight of the Tower*, Sebastian Brant's satirical poem *The Ship of Fools* and the *Comedies* of the Roman poet Terence. By the autumn of 1493 Dürer had travelled back through Colmar and reached Strasbourg. Two oil paintings survive from his stay, his first painted self-portrait (see Plate 4) and a devotional panel of *Christ as the Man of Sorrows* (Plate 5). Among his pen and ink drawings is a female nude, dated 1493 (see Fig. 4). The preliminary drawing is visible and this shows that Dürer made substantial adjustments to the work, such as on the upper thigh. This little sketch, perhaps done in a bathhouse, represents the earliest surviving life drawing in Northern art. The squat girl, her hair wrapped in a towel, is faithfully depicted, unadorned and unidealized.

When Dürer finally returned to Nuremberg in May 1494 he was 23, fully-trained and could open his own workshop. Albrecht the Elder had felt it was time for his son to marry and had chosen a wife during his long absence. On 7 July, just a few weeks after his return, Dürer was married to Agnes Frey, the daughter of the skilled and prosperous coppersmith Hans Frey. It was probably just before their wedding that Dürer sketched his fiancée, then in her late teens (see Fig. 5). Capturing her pensive mood with just a few strokes of the pen, Dürer lovingly inscribed it: 'My Agnes'.

Only a few weeks after the wedding, Dürer abandoned his young wife and set off for Italy. Why he left Agnes behind remains unclear. There was an outbreak of the plague in Nuremberg, but although this might account for his abrupt departure, it hardly explains why he left

his wife behind. Dürer left in September 1494 and it would have taken several weeks for the journey over the Alps to Venice. Both on the outward trip, and on the return, he did a series of watercolour landscapes. These include a set of watercolours of Innsbruck and he also painted the Italian towns of Trento and Arco (see Plate 8) and the nearby Cembra Valley.

Dürer was excited by Venice. It was not only the richest city in Europe, but also the gateway to the East. Dürer was fascinated by its people, and he sketched Venetian ladies in elegant robes and costumed Turkish men. One of the bejewelled young women he drew (Graphische Sammlung Albertina, Vienna) may well have been a courtesan, since she was to reappear a few years later as the Whore of Babylon in 'The Apocalypse', a series of woodcuts. Dürer also saw the Mediterranean for the first time and, intrigued by its sea creatures, he carefully depicted a crab (Museum Boymans-van Beuningen, Rotterdam) and a lobster (Kupferstichkabinett, Berlin).

German painters had for decades been attracted by the art of the Netherlands, but Dürer seems to have been the first artist who also looked south to Italy for inspiration. At the time of his arrival, Venice's distinguished artists included Gentile Bellini (c1429–1507) and his brother Giovanni (c1430–1516), Vittore Carpaccio (c1460–1523/6) and Cima da Conegliano (c1459–1517/18), all renowned for their highly developed sense of colour. Dürer was also interested in the work of Jacopo de' Barbari (active c1497–1515/16), a Venetian painter and engraver who was studying the depiction of the human form. Although on this occasion Dürer does not seem to have ventured to the other major centres of Italian art, he copied the engravings and drawings of artists such as Andrea Mantegna (c1431–1506) of Mantua and Antonio Pollaiuolo (c1432–98) and Lorenzo di Credi (c1458–1537) of Florence. Italian art was to have a strong influence on Dürer's own work, particularly in paintings such as the *Virgin and Child before an Archway* (Plate 7).

After spending the winter in Venice, Dürer set off for Nuremberg in the spring of 1495. He rejoined his wife Agnes and the couple set up home in his parent's house in Unter der Vesten. Dürer had now been away from Nuremberg for nearly five years, apart from a few weeks the previous summer. He was now ready to establish his own workshop and Nuremberg was an ideal base for an artist.

Nuremberg was a free city, part of the Holy Roman Empire but effectively governing itself. It was among the greatest trading cities of central Europe, with links down the Rhine to the Netherlands and over the Alps to Italy. Economically it was thriving. Its industries were based on metalwork and there was a long tradition of fine craftsmanship. The city was renowned for its strong community of humanist scholars. In the late fifteenth century it had also developed into one of the early centres of publishing.

Much of Dürer's early work was as a printmaker, designing woodcuts and making engravings. For woodcuts, the artist would first draw his design on a block of wood, marking the areas that were to be cut away and appear white in the prints. The cutting was done by another craftsman and the block was then inked and printed. Engraving, the other main technique, worked on the reverse principle. The lines removed from the copper plate with a cutter would appear black in the prints. The plate was engraved by the artist himself, a technique which would have been familiar to Dürer from his time spent as a goldsmith in his father's workshop. The engraved plate was then inked and wiped, leaving the ink in the grooves, and it was ready for printing.

Dürer's early prints were strongly influenced by the work of two earlier German printmakers. Schongauer, whom he had set out to visit

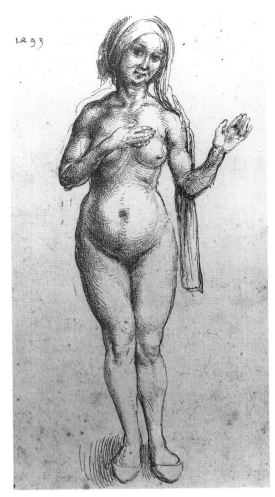

in Colmar, had produced graceful engravings of religious subjects. Dürer was also impressed by a printmaker now called the Master of the Housebook, whose identity is unknown but who worked in the Rhine Valley from the 1470s. He used the delicate technique of drypoint to give his engravings a light and spontaneous appearance. In drypoint, the lines are scratched with a sharp instrument held like a pen, rather than gouged out with the burin engraving tool.

Dürer's earliest signed print, and possibly the first done in his own workshop, is an engraving of *The Holy Family with a Dragonfly*, inscribed with an early form of his AD monogram and probably dating from 1494. Two years later he started work on 12 woodcuts on the death of Christ, known as 'The Large Passion', a project that was to take a further 15 years to complete. However, the greatest printmaking achievement of his early years was 'The Apocalypse', a set of 15 woodcuts on the revelations of St John (see Fig. 6). Telling the story of the end of the world and the coming of the Kingdom of God, this series of large prints displays great imagination and power.

In Dürer's day, prints were usually made for speculative sale and more copies could be run off if demand was high, but paintings were often produced on commission. The most expensive and durable works were oil paintings, supported on wooden panels. In Nuremberg, lime wood was normally used, although poplar was more common in Italy and oak in the Netherlands. Dürer also painted in tempera, an egg- or gelatine-based medium. He worked with tempera on canvas, and since this kind of paint did not take nearly as long to dry as oil, a picture could be completed much more quickly and it was therefore a cheaper technique.

When he set up his workshop, Dürer needed patrons for his paintings and he was soon more successful than he could have hoped, attracting for his first known commission no less a figure than Frederick the Wise, Elector of Saxony and one of the seven great princes of Germany. On a visit to Nuremberg in April 1496, Frederick the Wise asked Dürer to paint his portrait (see Plate 12). He probably also commissioned two altarpieces for the church at his palace at Wittenberg, which lay 200 miles to the north of Nuremberg. Of the first altarpiece, devoted to the Life of the Virgin, only the left half depicting the Seven Sorrows survives (see Plate 13). The second altarpiece is the triptych of the *Virgin between St Anthony the Hermit and St Sebastian* (Gemäldegalerie, Dresden). Other artists may well have been involved in producing this triptych and the degree of Dürer's personal involvement is unclear.

Frederick the Wise must have been pleased with Dürer. He later appears to have commissioned the artist to paint two further altarpieces, which were both completed in 1504. One of these was a triptych with wings depicting four saints on the inside and Job castigated by his wife on the outside (see Plate 26). The central panel has long since disappeared and the theme of the triptych, now known as the Jabach Altarpiece because it once belonged to the Jabach family, remains unknown. The other commission from Frederick the Wise was for *The Adoration of the Magi* (Plate 27), which is among Dürer's masterpieces.

Dürer's other patrons for religious works were wealthy Nuremberg citizens. The *Virgin and Child at a Window* (Fig. 24), with a delightful scene of *Lot Fleeing with his Daughters from Sodom* on the reverse (Plate 16), was painted in around 1498 for the Haller family, who were successful merchants. *The Paumgartner Altarpiece* (Plate 21), begun in the same year, was a triptych of the Nativity. Dürer used the features of the donors, the Paumgartner brothers, when he painted the two saints on the wings. A panel of the *Lamentation for Christ* (Plate 22) was commissioned by the goldsmith Albrecht Glim.

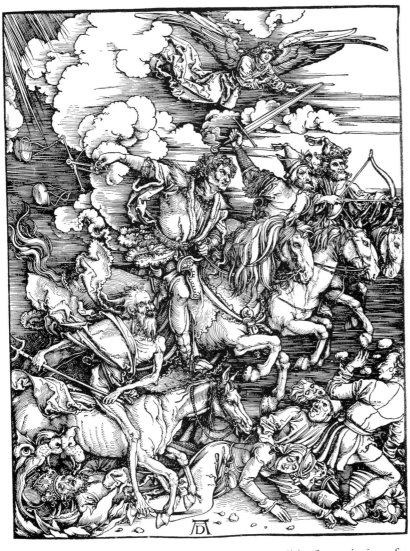

Fig. 6
The Four Horsemen
of the Apocalypse
1498. Woodcut, 39 x 28 cm.

Portraits were also in demand. In 1497 Dürer did a fine painting of a woman dressed in red, standing next to a window looking out over a landscape with distant hills (Gemäldegalerie, Berlin). The woman, whose identity is uncertain, may be Agnes Dürer's sister Katherina or a member of Nuremberg's Fürleger family. Two years later Dürer painted a striking portrait of the Lindau merchant Oswolt Krel (see Plate 17), with wings depicting a pair of wild, hair-covered men holding family coats of arms. He also did a set of four portraits of the Tucher family, the brothers Niclas and Hans and their wives Elsbeth and Felicitas (see Plate 18 and Figs. 25 and 26). For his own family, Dürer painted a second portrait of his elderly father in 1497 (see Plate 14) and another self-portrait the following year (see Plate 15). The culmination of these early portraits is Dürer's final self-portrait of 1500 (see Plate 19), depicting the 28 year-old artist in a Christ-like pose.

Throughout this period Dürer produced hundreds of drawings and watercolours. His landscapes of the late 1490s, such as *House by a Pond* (Plate 9), *Pond in the Woods* (Plate 10) and *Willow Mill* (Plate 11), are quite different from his earlier watercolours. There is now a much greater emphasis on capturing atmosphere, rather than depicting topography. Dürer also did a marvellous series of nature studies. In works such as *A Young Hare* of 1502 (Plate 23) and *The Large Turf* (Plate 24) of the following year, the artist succeeded in painting the detail of the animal or the vegetation without losing anything of their overall atmosphere and character.

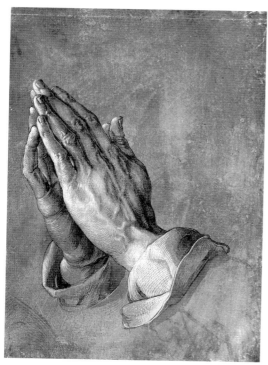

Fig. 7
Study of Praying
Hands
1508. Brush and ink
heightened with white on
blue tinted paper,
29 x 20 cm.
Graphische Sammlung
Albertina, Vienna

A decade after his first visit to Venice, Dürer decided to return. In the autumn of 1505 he set off across the Alps, once again leaving Agnes behind in Nuremberg. Their marriage, which was childless, does not seem to have been close. Dürer would occasionally sketch Agnes, but except for the first drawing done at the time of their marriage (see Fig. 5), there seems to be little tenderness in these works. In most of his sketches of Agnes, the artist appears to have used his wife as a convenient model, whether depicting the type of dress worn in church (see Plate 20) or providing the figure of a saint (see Plate 42). Agnes also helped her husband by selling his prints. She, along with Dürer's mother Barbara, would sell his woodcuts and engravings at the annual fair in Nuremberg and on at least one occasion she went to Frankfurt for the Easter market.

Agnes has probably been unfairly blamed for problems in the Dürers' marriage. Pirckheimer, who did not get on with Agnes, once accused her of his friend's death: 'She watched him day and night, drove him to work hard for this reason alone that he might earn money and leave it her when he died.' It is difficult to believe the truth of this bitter remark, but Dürer's decision to twice visit Italy alone strongly suggests that they lived fairly independent lives. The artist, with his keen mind, may simply have found his wife insufficiently intellectual.

Wherever any blame lay, it is difficult to imagine Dürer writing to Agnes in the warm tones that he reserved for Pirckheimer. On his arrival in Italy in the autumn of 1505, he wrote to his friend: 'I wish you were here in Venice! There are so many nice fellows among the Italians who are my companions more and more every day, so that it warms my heart: intelligent, educated, good lute players, flautists, connoisseurs of painting, and many noble minds...On the other hand, there are also among them some of the most false, lying, thievish rascals, the like of which I wouldn't have believed lived on earth.' Among the villains, he presumably included Marcantonio Raimondi(c1480–1527/34), an Italian painter and engraver who had copied his prints. Dürer took him to court, in what was perhaps the first lawsuit in history over artistic copyright. Although Raimondi was not barred from copying Dürer's designs, he was prohibited from including the AD monogram.

Dürer was already known as the greatest German printmaker, but he soon dazzled the Venetians with his painting. 'I have stopped the mouths of all the painters who used to say I was good at engraving, but, as to painting, I did not know how to handle my colours. Now everyone says that better colouring they have never seen,' he proudly told Pirckheimer. While in Venice, Dürer painted the portrait of Burkard von Speyer (see Plate 29), as well as portraits of two women, one a gentle girl painted in harmonious orange-browns and flesh tones (see Plate 28) and the other a slightly older woman depicted against a blue background, possibly the sea (Gemäldegalerie, Berlin). Dürer also did a radiantly coloured picture known as *The Madonna with the Siskin* (Gemäldegalerie, Berlin), named after the bird which is perched on the Christ child's shoulder.

By far the most important of Dürer's Venetian works, and the one which earned him his reputation for handling colour, is the altarpiece commissioned by the German merchants for the Church of San Bartolomeo. Known as *The Altarpiece of the Rose Garlands* (Plate 30), it depicts the Virgin distributing garlands to worshippers, led by the Pope and the Emperor. It was as a result of this magnificent altarpiece that the Venetian authorities offered Dürer a salary of 200 ducats a year if he would stay and work in their city. He declined, but with a twinge of regret. 'How I shall yearn for the sun! Here I am a gentleman, at home

only a parasite,' he wrote to Pirckheimer towards the end of his stay.

Before heading back to Nuremberg, Dürer first travelled south. At the end of October 1506 he set off for Bologna to see an expert who had promised to teach him 'the secrets of the art of perspective'. There has been much speculation about who this was, but it might well have been the mathematician Fra Luca Pacioli. Dürer then probably went further south to Florence to see the works of Leonardo da Vinci (1452–1519) and Raphael. From there Dürer may well have gone to Rome, where it is thought that he painted the panel of *Christ among the Doctors* (Plate 31). He must then have returned home via Venice.

The influence of Dürer's Italian trip can be seen in the two life-size panels of Adam and Eve (see Plate 32), which he painted soon after his return in February 1507. The nudes are Venetian in style and were part of Dürer's quest to depict the perfect human figure. Also from the same year, and done either in Venice or on his return, is a portrait of a well-dressed young man (Kunsthistorisches Museum, Vienna). Even more striking is what is on the reverse of this panel: the ugly figure of a wrinkled old woman, with one sagging breast hanging out of her cloak. In her hands she clasps a large bag of gold coins. This serves as a reminder of the transience of life and the worthlessness of earthly goods, and is known as a *vanitas* image.

Soon after Dürer's return to Nuremberg, Frederick the Wise commissioned yet another altarpiece, this one for the relic chamber of his church at Wittenberg. Completed in 1508, it is a gruesome depiction of *The Martyrdom of the Ten Thousand* (Plate 33). By this time Lucas Cranach (1472–1553) had just been appointed court painter at Wittenberg and the panel of the martyred Christians was to be Dürer's last commission for the Elector.

Dürer was also working on an altarpiece for the Frankfurt cloth merchant Jacob Heller. While away in Venice his workshop had already begun painting the wings and Dürer himself did the central panel depicting the Coronation of the Virgin. He made numerous preparatory studies, including his famous *Study of Praying Hands* (Fig. 7), prepared for the figure of the kneeling apostle at the right of the panel. *The Heller Altarpiece* was finally completed in August 1509 and later placed in Frankfurt's Dominican church. There was a bitter dispute over payment, and Dürer eventually accepted 200 florins, half what he had demanded. In one of his letters, Dürer told Heller: 'I have painted it with great care, as you will see, using none but the best colours...If it is kept clean I know it will remain bright and fresh for 500 years.' Tragically, this was not to be, and the panel was destroyed in a fire at the Residenz in Munich in 1729. Only an early seventeenth-century copy of the central panel survives (see Fig. 8), painted by the Frankfurt artist Jobst Harrich (1580–1617).

The third altarpiece which Dürer completed during this period also contained a multitude of figures, a panel of *The Adoration of the Holy Trinity* (Plate 34). It was commissioned in 1508 by the wealthy Nuremberg metal-smelter Matthäus Landauer for the chapel of his Twelve-Brothers House, an almshouse set up to care for a dozen elderly artisans. Dürer also designed the intricately carved wooden frame for the painting, as well as stained-glass windows for the chapel, and the project took three years to complete.

Dürer continued to paint portraits, including a fine panel of his former master, Wolgemut (see Plate 39). The aged artist, who in 1516 was about 80, was starkly portrayed against a plain, deep-green background. By this time Dürer was avoiding the landscape backgrounds that he had used in his earlier portraits, presumably because he felt them to be a distraction. In his portraiture, he now focuses all attention

Fig. 8
JOBST HARRICH
The Heller Altarpiece
(copy after Dürer)
*c*1614. Oil on panel,
189 x 138 cm.
Historisches Museum,
Frankfurt

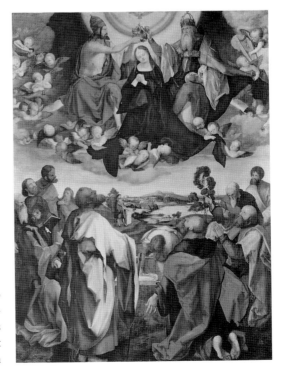

Fig. 9
Portrait of Dürer's
Mother
1514. Charcoal on paper,
41 x 30 cm.
Kupferstichkabinett,
Berlin

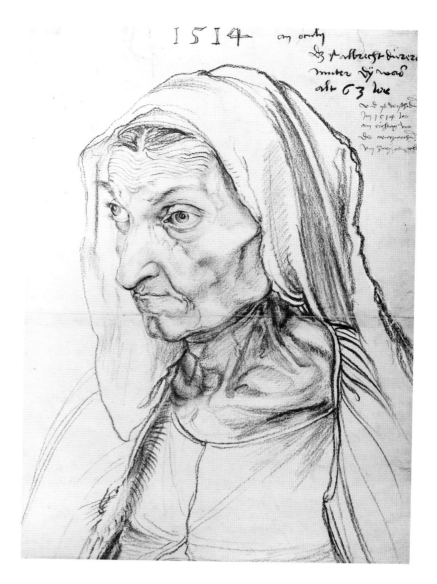

on the head, shown in close-up and often tightly placed in the frame. Another of Dürer's portraits of 1516 depicts a clergyman, probably Johann Dorsch of Nuremberg (National Gallery of Art, Washington DC). In the same year he painted the heads of two apostles, Philip and James (see Plate 40 and Fig. 37), who have extremely anguished faces. These may well have been intended as part of a set of the 12 apostles.

In 1509 Dürer had been made a member of Nuremberg's Grand Council. This body, consisting of 200 leading citizens, had little real power, but the appointment was a sign of the artist's growing recognition. Four years later Dürer received his first commission from the city, to paint a pair of portraits of Charlemagne and Sigismund (see Plate 37). These panels were to hang in the Treasure Chamber where the precious regalia of the Holy Roman Emperors were kept just before they went on their annual public display. Eight years later Dürer was also commissioned to design murals for the main chamber of the city hall, but these were painted with unstable materials and started to deteriorate quickly, lasting only a century. Despite these two commissions, Dürer was resentful at the lack of support he had received from his own city. In 1524 he wrote to the council, complaining that 'for the 30 years in which I have been a resident of this city I have not received commissions from it of as much as 500 florins, which is a laughable sum...I have earned my living, and a hard one it has been, entirely from princes, lords and other strangers.'

Yet Dürer never left Nuremberg to live elsewhere. As he explained in his letter: 'I preferred to live in a modest house among your excellencies, rather than become rich and admired elsewhere.' But by this time, Dürer's lifestyle was far from modest. His father had died in 1502 and he had then continued to live at the family house in Unter der Vesten with Agnes and his mother Barbara. Although he had accumulated some debts when he left for Venice in 1505, he earned a good deal there, and four years later he moved into a larger house in Zisselgasse, the former home of the astronomer Regiomontanus and later his pupil Bernhard Walther. Dürer's aged mother came with him to Zisselgasse and he continued to care for her. On 19 March 1514 he did a magnificent, almost life-size drawing which captured the 63 year-old woman's gaunt features (see Fig. 9). Two months later, on 17 May, she was dead.

In his workshop, Dürer could afford to employ more assistants. By 1503 he had three journeymen, all called Hans. Hans Süss (c1480–c1522) from Kulmbach had started with Dürer in 1500 and 11 years later he established his own workshop in Nuremberg. Hans Baldung Grien (c1484–1545), the most talented of the trio, supervised Dürer's workshop while he was away in Venice in 1505–6 and left shortly after his return, moving to Strasbourg. The third journeyman, Hans Schaufelein (c1483–1539/40), stayed until 1510 and then went to Augsburg. There was also a fourth Hans at the workshop, Dürer's younger brother, who helped paint the wings of *The Heller Altarpiece*. Hans Dürer, who had been born in 1490, later left Nuremberg for Poland and became court painter in Cracow in 1529.

The three main specialities of Dürer's workshop continued to be paintings, prints, and to a lesser extent designs for stained glass. Dürer found that panel paintings were not very profitable and in one of his letters to Heller he suggests that his painting of the Coronation of the Virgin (destroyed in 1729) might be his last altarpiece: 'No one shall ever compel me to paint a picture again with so much labour...Henceforth I shall stick to my engraving,' he wrote. In subsequent years he did indeed devote much of his time to prints, bringing to fruition several series which he had started years earlier. In 1511 he completed the 20 woodcuts of 'The Life of the Virgin' (see Fig. 27) and the 12 major woodcuts of 'The Large Passion' (see Fig. 28), both of which were published in book form. Between 1509 and 1511 he produced the 37 woodcuts of 'The Small Passion' and between 1507 and 1513 the 16 sheets of 'The Engraved Passion'. Dürer also experimented with other printmaking techniques, including drypoint which had been used by the Master of the Housebook, as well as etching on iron plates.

Dürer's greatest achievement in printmaking were the three engravings of 1513–4, regarded as his masterpieces. *Knight, Death and the Devil* (Fig. 10), also known as *The Rider*, represents an allegory on Christian salvation. The horseman in armour rides on, ignoring the frightening horned devil behind him. Steadfastly, the armoured knight looks away from the gaunt figure of Death, who brandishes an hourglass. The rider advances, contemptuous of the lurking threats – a symbol of courage.

St Jerome in his Study (Fig. 11) is very different, stressing the contemplative rather than the active aspect of Christian life. The engraving shows the translator of the Bible deep in thought at his lectern, with the figure of the saint illuminated by sunlight streaming through the window panes into the cosy room. In front of St Jerome are the resting figures of his faithful lion and dog. A skull on the windowsill and an hourglass above the saint are reminders of the transience of life. The astonishing advance in Dürer's printmaking technique is evident when this engraving is compared with his early woodcut of the same subject (see Fig. 3).

Fig. 10 *(overleaf)*
Knight, Death and
the Devil
1513. Engraving, 24 x 19 cm.

Fig. 11 *(overleaf)*
St Jerome in his Study
1514. Engraving, 24 x 19 cm.

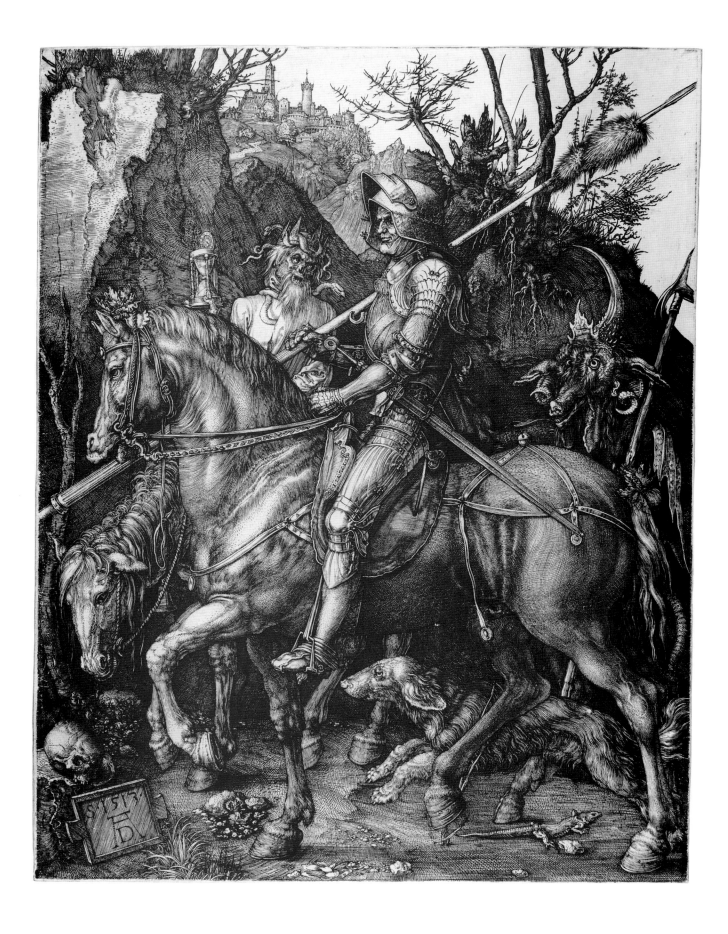

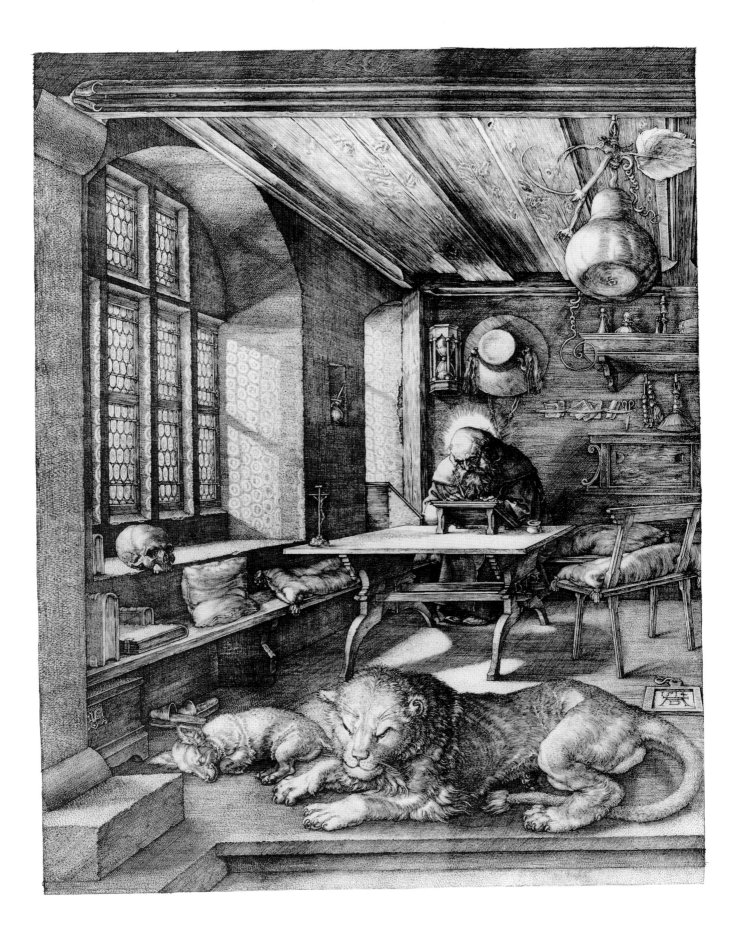

Fig. 12
Melencolia I
1514. Engraving, 24 x 19 cm.

Melencolia I (Fig. 12) is by far the most complex of the three master engravings. The winged genius, representing the figure of Melancholy, rests her head on her hand, in a reflective pose, and holds a compass. Around her are geometric shapes, including a sphere and a giant polyhedron, along with scattered woodworking tools. On the wall of the building hang a bell, an hourglass, scales and a magic square of 16 numerals (with each line adding up to 34). A dog sleeps at Melancholy's feet and a cherub sits astride an upturned millstone. A bat-like creature holds up the inscription 'Melencolia I'. Although the precise meaning of the image is now elusive, it deals with the relationship between melancholy and creativity. While melancholy may take away enthusiasm for creativity, it is often a characteristic of the creative.

After completing his three master engravings, Dürer's spent much of his time on working for the highest figure in the land, the Holy Roman Emperor. Maximilian I, who had made the Habsburgs the dominant European power, was a great patron of the arts and Dürer met him on a visit to Nuremberg in February 1512. The artist was then commissioned to design a huge print, *The Triumphal Arch*, to celebrate the Emperor's achievements. This monumental project, composed of 192 woodblocks and 11 feet high, is still the largest woodcut print ever made. Modelled on a Roman arch, it depicts Maximilian enthroned above the archway. On the side portals 24 major events from his reign are shown and the whole work is covered with intricate and symbolic ornamentation. Dürer's overall design was completed by his assistants and finished in 1515.

After *The Triumphal Arch*, Maximilian ordered *The Triumphal Procession*, which was to have consisted of 208 woodblocks. When the Emperor died in 1519 only 139 of the woodblocks had been completed, but when these were eventually printed the procession stretched to 180 feet. Dürer played a minor role in this project, producing just the two key woodblocks for the wedding chariot of Maximilian and Mary of Burgundy. He also did a further eight woodblocks for *The Great Triumphal Chariot*. These grandiose prints were intended to glorify the image of Maximilian and from an artistic point of view they can have given Dürer little satisfaction.

On a very different scale was Dürer's work on the personal prayer book of Maximilian. The Emperor had selected a series of prayers and hymns, which were produced as a printed book in 1513. Dürer, together with other German artists, was then commissioned to decorate the borders of the Emperor's own copy. Dürer filled the margins of 45 pages with pen and ink sketches, using a mixture of German late-Gothic and Italian Renaissance ornamentation to provide an imaginative commentary on the text. To accompany a prayer on the dangers of temptation, for example, he sketched a fox as the tempter, playing an enticing tune on his flute to attract a flock of chickens. Other artists who decorated the remaining pages included Cranach, Albrecht Altdorfer (*c*1480–1538) of Regensburg and Dürer's former journeyman Baldung. Until this point Dürer had worked for Maximilian without charge, presumably for the honour, but in September 1515 the Emperor promised him an annual payment of 100 florins. This sum was to come from the taxes collected on his behalf in Nuremberg. Dürer met Maximilian again on 28 June 1518, during the Imperial Diet, and sketched his portrait (Fig. 38) 'up in his small chamber in the tower at Augsburg'. This drawing was later used as the basis for two painted portraits (see Plate 41) and a woodcut. Maxmilian died on 12 January 1519 and this created financial problems for Dürer since the Emperor's annual payment was stopped.

At the age of 49, Dürer set off on what was to be his last long journey, to the Netherlands. The country was also ruled by the Habsburgs and

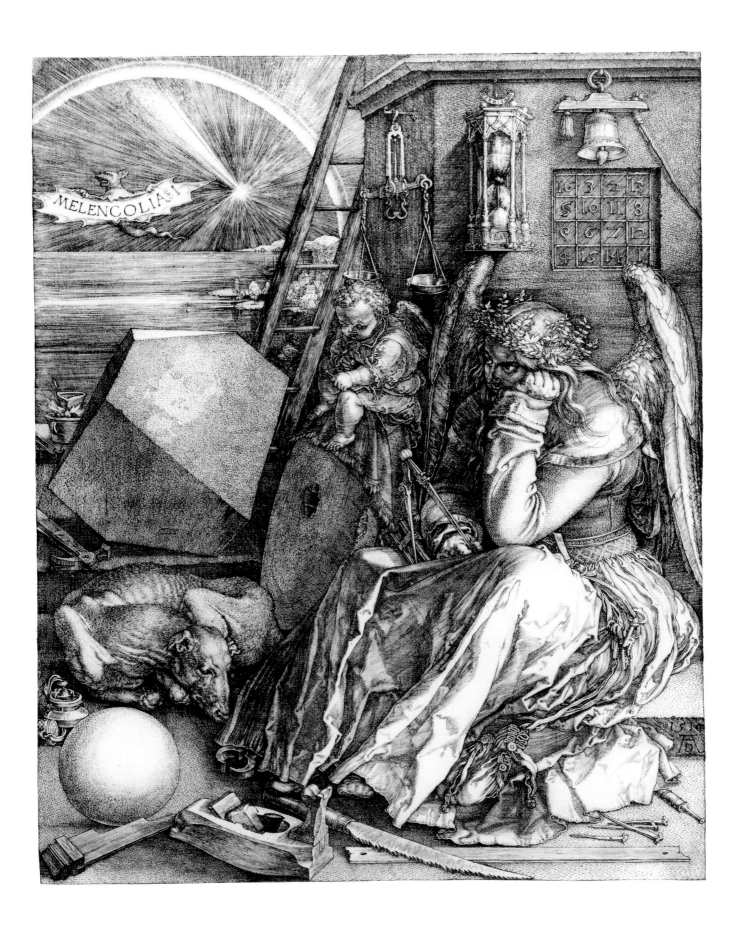

the area which Dürer visited was Flanders (present-day Belgium), where most of the artists were then based. While the main reason for the trip was to get the new emperor Charles V to confirm his annual payment, he was also keen to see the masterpieces of Netherlandish art, to meet the artists, and enjoy the sights. Dürer left home on 12 July 1520, this time accompanied by his wife Agnes and their maid Susannah, and they travelled by boat down the Main and the Rhine. In Cologne they stayed with Dürer's cousin, Niclas, who was a master goldsmith. On 2 August they finally arrived in Antwerp, the bustling trading centre which was to be their base. There Dürer was received as visiting dignitary. Among the important painters he was to meet in the Netherlands were Quentin Massys (c1464–1530), Joos van Cleve (c1485–1540/1), Joachim Patenier (active 1515–24), Lucas van Leyden (c1494–1533), Bernard van Orley (c1491–1541) and Jan Provost (c1462–1529).

After Antwerp, Brussels was the next stop. There Dürer met Erasmus (see Fig. 13), the humanist scholar, and sketched his portrait which six years later he would use as the basis for an engraving. One of the highlights of the visit to the city was the opportunity to see the Aztec treasures which the Spanish conquistador Hernán Cortés had acquired in Mexico. 'I saw the rings which have been brought to the King from the new land of gold...and all manner of wondrous weapons of theirs, harness and darts, very strange clothing, beds, and all kinds of wonderful objects....These things were all so precious that they are valued at 100,000 florins. All the days of my life I have seen nothing that rejoiced my heart so much,' he recorded in his diary. On 23 October Dürer was in Aachen to attend the coronation of Charles V. There was no chance to get a decision from the new Emperor about his annual payment, so he followed the imperial court to Cologne, and on 12 November it was confirmed.

On 3 December Dürer then set off for a short trip to Zeeland, at the mouth of the Rhine, where he wanted to see a whale which had been stranded on the beach. It was to be a journey plagued by misfortune. Dürer was first nearly drowned in a shipping accident. When he finally reached the beach where he hoped to see, and presumably sketch, the whale, he discovered that the tide had carried away 'the great fish'. Finally, and most seriously, he caught 'a strange sickness...such as I have never heard of from any man.' This illness, which was to recur, may well have been malaria.

Dürer returned to Antwerp on 14 December and stayed there for the winter. The most important painting he completed was a panel of St Jerome (see Plate 43), modelled on a 93 year-old man he had sketched. Dürer gave the picture to his friend the Portuguese consul, Rodrigo Fernandez d'Almada. In April 1521 he briefly visited the Flemish cities of Bruges and Ghent, seeing masterpieces such as Michelangelo's sculpture of the *Virgin and Child* in the Church of Our Lady in Bruges and Van Eyck's *Adoration of the Lamb* in Ghent Cathedral. On 6 June Dürer went to Mechelen to meet Margaret of Austria, Governor of the Netherlands and the daughter of Maximilian I, who had helped arrange the continuation of his annual payment. Dürer was then invited to Brussels on 3 July to paint the portrait of Christian II, King of Denmark, a work which has sadly disappeared. Towards the end of his time in Antwerp, Dürer was offered a salary of 300 florins a year by the city council to stay and work, but he decided to return home.

Dürer, Agnes and their maid Susannah arrived back in Nuremberg at the end of July 1521. The primary purpose of the trip had been accomplished, the renewal of the Emperor's financial payment. A month after their arrival Dürer collected 200 florins and from then on the payments were regular. The trip had also been a success from an artistic point of

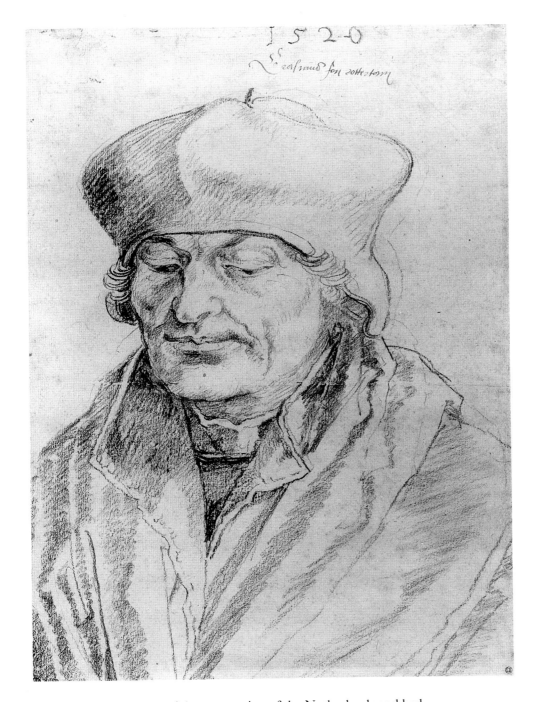

Fig. 13
Portrait of Erasmus
1520. Charcoal on paper,
37 x 27 cm.
Cabinet des Dessins,
Musée du Louvre, Paris

view. He had met most of the great artists of the Netherlands and had seen much of their work. He had sold or given away a substantial number of his prints and in return he came back laden with exotic treasures. Among the souvenirs which he proudly recorded acquiring in the Netherlands were Indian coconuts, a small ivory skull, bamboo canes, a giant fish-scale, white coral, buffalo horns, an elk's hoof, parrots, a baboon, the branch of a cedar tree, a tortoise, native boxing gloves, rubies and an old Turkish whip.

During Dürer's visit to the Netherlands the religious upheaval of the Reformation had intensified. On 31 October 1517 the Augustinian monk Martin Luther had nailed a notice on the wooden door of the palace church at Wittenberg, condemning the sale of indulgences. This church was home to a number of Dürer's altarpieces and this must have made him even more concerned about events. Dürer soon decided that his sympathies lay with reform. As a measure of his support, he wanted to make a print of Luther's portrait. 'If God will

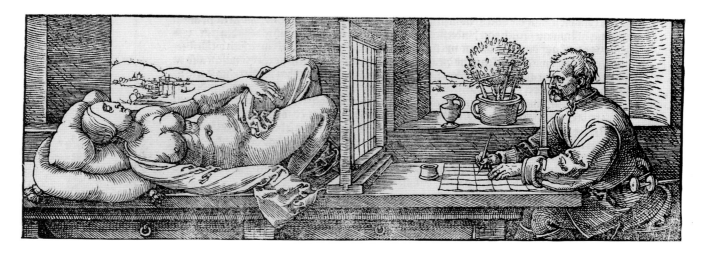

Fig. 14
Draughtsman
Drawing a
Recumbent Woman
1525. Woodcut, 8 x 22 cm.
From *Manual of
Measurement*

allow me to meet Dr Martin Luther, I will diligently draw his likeness for an engraving, so as to keep alive the memory of this Christian man, who has helped me in moments of great anxiety,' the artist wrote in 1520 to George Spalatin, a member of the court of Frederick the Wise. By this time the Elector was backing Luther's call for reform.

It had been while Dürer was away in Antwerp, on 17 May 1521, that he heard reports that Luther had been betrayed and probably murdered. In an uncharacteristically emotional passage in his diary, Dürer inveighs against the papacy and laments the loss of Luther: 'Oh God, if Luther be dead, who will henceforth expound to us the Holy Gospel with such clarity? What, oh God, might he not still have written for us in ten or twenty years!' It soon emerged that Luther had been hidden away for his own protection and was safe. The Reformation was now spreading throughout Germany and in 1525 the city authorities in Nuremberg decided to accept Luther's call for reform. Dürer backed this decision, despite his concerns about the spread of fanaticism. Although he remained uneasy about a complete break with his Catholic past, he supported Luther's doctrine within the framework of a common Christian faith.

In Dürer's later years he devoted an increasing proportion of his time to writing about art rather than practising as an artist. In 1508 he had started work on a handbook, entitled 'Nourishment for Young Painters'. It was to consist of three sections. The first would deal with the spiritual and practical training of apprentices. The second part was to cover theoretical issues such perspective, light, colour and the proportions of the human body. The final section would deal with how a painter should live and encourage him to give thanks to his Creator. Dürer worked at the text for years and in the introduction, drafted in 1512, he explained his philosophy, emphasizing the religious dimension of art, but accepting its secular importance: 'The art of painting is used in the service of the Church and shows the suffering of Christ, and it also preserves the image of men after their death.' It was also in this draft introduction that Dürer wrote his famous words, 'What beauty is I do not know. Nobody knows it but God.' His proposed handbook was ambitious, considering that so little had been written on the art of painting, and this may explain why he was never able to complete it.

The first book that Dürer actually finished was his *Manual of Measurement*, published in 1525. It deals with geometry and its importance to the artist, a subject which Dürer believed was fundamental because so many young artists lacked the necessary theoretical knowledge to become good painters. 'Even if some of them acquire a good hand through constant practice, they produce work instinctively and

without thought,' he wrote. The book includes practical advice on how to draw accurate pictures with the help of various devices. These included an upright grid of wires through which the artist views his subject, sketching it on a similar grid on his paper (see Fig. 14). Dürer's subsequent book, published two years later, was on military defences. Entitled *Various Instructions for the Fortification of Towns, Castles and other Localities*, it too was largely based on the science of geometry.

Dürer's most important contribution to the theoretical study of art was his work on the question of human proportion, a problem which arose from the Italian artists' search for the ideal measurements of the body. After years of study, Dürer ultimately decided that there was no absolute ideal. Choosing the head as the basic measurement for other parts of the human body, he established a series of proportions devised according to different physiques. His theory was published in his *Four Books on Human Proportion*, but although he had begun to correct the proofs it was not not published until six months after his death (see Fig. 15).

Dürer painted little in his later years, although he completed several fine portraits. Either in the Netherlands or on his return he did a striking portrait of a frowning man with pursed lips (Museo Nacional del Prado, Madrid), possibly the Brabant treasurer Lorenz Sterck. In 1526 he painted the Nuremberg councillors Hieronymous Holzschuher (see Plate 46) and Jacob Muffel (Gemäldegalerie, Berlin). These portraits make an interesting contrast, Holzschuher is firm and tough, while Muffel is much gentler and more thoughtful. In the same year Dürer also painted the portrait of the merchant Johannes Kleberger (see Plate 47). Two years later Kleberger married Pirckheimer's

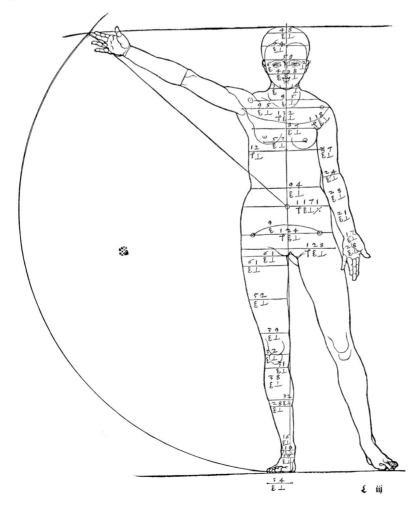

Fig. 15
Figure of a Woman
Shown in Motion
1528. Woodcut, 22 x 16
cm. From *Four Books on Human Proportion*

favourite daughter and then promptly abandoned his new wife, emigrating to France and later giving away all his wealth. In 1526 Dürer painted the last version of his favourite subject, the Madonna. *The Virgin with the Pear* (Galleria degli Uffizi, Florence) depicts a deeply reflective Madonna offering the fruit to her chubby child. Dürer's final oil paintings, dating from 1526, were the pair of panels of *The Four Holy Men* (Plate 48). On the left side are the life-size figures of John and Peter, with Paul and Mark the Evangelist on the right. These works were presented to the city council as a gift from the artist.

Dürer died on 6 April 1528, just short of his 57th birthday. Although he was often unwell in his last years, death came suddenly. Dürer was probably killed by the fever which he had contracted in Zeeland on his unsuccessful search for the beached whale. He was buried in the graveyard of St John's Church, near the spot where he had painted one of his first watercolour landscapes in 1489 (see Plate 1). Dürer died only too aware that there was so much more left to do. As he had written in the draft of his 'Nourishment for Young Painters', a good artist always has more to express: 'If it were possible that he lived forever, his inner ideas...would always give him something new to express through his works.'

His loyal friend Pirckheimer wrote the epitaph on his grave: 'What was mortal of Albrecht Dürer lies under this stone.' Dürer's body was allowed to rot and, as was the custom, the bones were removed some years later to make way for another corpse. All that remains of his body is a lock of his long hair, presented at his death to his greatest pupil, Baldung. These strands of Dürer's hair are still preserved in a silver reliquary at the Academy of Fine Arts in Vienna.

Pirckheimer's prediction that his friend's work would survive quickly proved correct. Dürer was to dominate the development of German art in the sixteenth century and his influence rapidly spread to Italy and the Netherlands and throughout Europe. Even now, five centuries later, Dürer remains the greatest of German artists.

Outline Biography

1471 Albrecht Dürer born 21 May in Nuremberg, son of Albrecht Dürer the Elder, goldsmith, and Barbara Holper. The family live in Winklerstrasse.

1475 On 12 May Dürer's family moves to Unter der Vesten (now Burgstrasse).

c1479–82 Dürer attends school.

c1482 Starts to learn the goldsmith's craft in his father's workshop.

1484 Birth of Endres Dürer on 25 April (d.1555).

1486 On November 30 apprenticed in the workshop of Nuremberg artist Michael Wolgemut in Unter der Vesten.

1489 Completes apprenticeship at end of year.

1490 Birth of Hans Dürer on 21 February (d.1538). In mid-April Dürer leaves for four-year journeyman travels, probably initially visiting Cologne and possibly the Netherlands.

1492 Visits Colmar and moves to Basle early in the year.

1493 Visits Strasbourg in the autumn.

1494 Arrives back in Nuremberg soon after 18 May. On 7 July marries Agnes, daughter of coppersmith Hans Frey. In September Dürer leaves his new wife to travel to Venice.

1495 Arrives back in Nuremberg in the late spring and lives with Agnes in the house of his parents. Establishes his own workshop shortly afterwards.

1496 Frederick the Wise, Elector of Saxony, visits Nuremberg 16–18 April and commissions work from Dürer.

1502 Death of Dürer's father Albrecht the Elder on 20 September, aged 75.

1505 Leaves for Venice in the autumn.

1506 Visits Bologna in October and probably then Florence and Rome, before returning to Venice.

1507 Arrives back in Nuremberg in February.

1509 Moves to new house in Zisselgasse in June (now Dürer Museum in Albrecht Dürer Strasse). Appointed to Nuremberg's Grand Council.

1512 Starts work for Maximilian I after meeting the Emperor in February.

1514 Death of Dürer's mother Barbara Holper on 17 May, aged 63.

1515 Maximilian offers Dürer annual retainer of 100 florins in September.

1518 Visits Augsburg in the summer for the Imperial Diet in June.

1519 Death of Maximilian on 12 January.

1520 Leaves with Agnes on 12 July for the Netherlands, visiting Antwerp, Brussels, Aachen, Cologne and Zeeland. On 12 November his annual payment is confirmed by Charles V.

1521 Based in Antwerp, he visits Bruges, Ghent, Mechelen and Brussels, returning to Nuremberg at the end of July.

1525 Publishes *Manual of Measurement*. Frederick the Wise dies on 5 May.

1527 Publishes *Various Instructions for the Fortification of Towns, Castles and other Localities*.

1528 Dies in Nuremberg on 6 April. Buried in St John's churchyard. *Four Books on Human Proportion* published in October.

Select Bibliography

Wilhelm Waetzoldt, *Dürer and his Times*, London, 1950

Erwin Panofsky, *The Life and Art of Albrecht Dürer*, Princeton, 1955

William Martin Conway, *The Writings of Albrecht Dürer*, London, 1958

Willi Kurth, *The Complete Woodcuts of Albrecht Dürer*, New York, 1963

Karl-Adolf Knappe, *Dürer: The Complete Engravings, Etchings, and Woodcuts*, London, 1965

H T Musper, *Albrecht Dürer*, London, 1966

Heinrich Wölfflin, *Drawings of Albrecht Dürer*, London, 1970

J-A Goris and G Marlier, *Albrecht Dürer: Diary of his Journey to the Netherlands 1520–1*, London, 1971

Angela Ottino della Chiesa, *The Complete Paintings of Dürer*, London, 1971

Charles W Talbot (ed.), *Dürer in America: His Graphic Work*, exhibition catalogue, National Gallery of Art, Washington DC, 1971

Christopher White, *Dürer: The Artist and his Drawings*, Oxford, 1971

Heinrich Wölfflin, *The Art of Albrecht Dürer*, London, 1971

Walter Koschatzky and Alice Strobl, *Dürer Drawings in the Albertina*, London, 1972

Francis Russell, *The World of Dürer 1471–1528*, Amsterdam, 1972

Walter Koschatzky, *Albrecht Dürer: The Landscape Water-colours*, London, 1973

Walter L Strauss, *The Complete Engravings, Etchings, and Drypoints of Albrecht Dürer*, New York, 1973

Walter L Strauss, *The Complete Drawings of Albrecht Dürer*, New York, 1974

Fedja Anzelewsky, *Dürer: His Art and Life*, London, 1980

Walter L Strauss, *The Intaglio Prints of Albrecht Dürer: Engravings, Etchings and Drypoints*, New York, 1980

Walter L Strauss, *The Woodcuts and Woodblocks of Albrecht Dürer*, New York, 1980

Peter Strieder, *Dürer*, Danbury, CT, 1984

Jan Bialostocki, *Dürer and his Critics 1500–1971*, Baden-Baden, 1986

Gothic and Renaissance Art in Nuremberg 1300–1550, exhibition catalogue, Metropolitan Museum of Art, New York, 1986

Fritz Koveny, *Albrecht Dürer and the Animal and Plant Studies of the Renaissance*, Boston, 1988

Peter Strieder, *Albrecht Dürer: Paintings, Prints, Drawings*, New York, 1989

Jane Campbell Hutchison, *Albrecht Dürer: A Biography*, Princeton, 1990

Fedja Anzelewsky, *Albrecht Dürer: Das Malerische Werk*, Berlin, revised edition 1991

Colin Eisler, *Dürer's Animals*, Washington, 1991

Joseph Leo Koerner, *The Moment of Self-portraiture in German Renaissance Art*, Chicago, 1993

John Rowlands, *Drawings by German Artists*, British Museum catalogue, London, 1993

List of Illustrations

Colour Plates

1 Saint John's Church
 c1489.Watercolour and gouache on paper,
 29 x 42 cm.
 Formerly Kunsthalle, Bremen
 (temporarily Hermitage, St Petersburg)

2 The Wire-drawing Mill
 c1489.Watercolour and gouache on paper,
 29 x 43 cm. Kupferstichkabinett, Berlin

3 Portrait of Dürer's Father
 1490. Oil on panel, 48 x 40 cm.
 Galleria degli Uffizi, Florence

4 Self-portrait at 22
 1493. Oil on linen, transferred from vellum,
 57 x 45 cm. Musée du Louvre, Paris

5 Christ as the Man of Sorrows
 c1493. Oil on panel, 30 x 19 cm.
 Staatliche Kunsthalle, Karlsruhe

6 St Jerome in the Wilderness
 c1495. Oil on panel, 23 x 17 cm.
 National Gallery, London

7 Virgin and Child before an Archway
 c1495. Oil on panel, 48 x 36 cm.
 Fondazione Magnani-Rocca, Parma

8 View of Arco
 1495. Watercolour and gouache on paper,
 22 x 22 cm. Cabinet des Dessins, Musée du
 Louvre, Paris

9 House by a Pond
 c1496. Watercolour and gouache on paper,
 21 x 23 cm. British Museum, London

10 Pond in the Woods
 c1496. Watercolour and gouache on paper,
 26 x 37 cm. British Museum, London

11 Willow Mill
 c1496–8. Watercolour and gouache on paper,
 25 x 37 cm. Cabinet des Estampes, Bibliothèque
 Nationale de France, Paris

12 Portrait of Frederick the Wise
 1496. Tempera on canvas, 76 x 57 cm.
 Staatliche Museen zu Berlin – Preussischer
 Kulturbesitz Gemäldegalerie, Berlin

13 The Seven Sorrows of the Virgin
 c1496–7. Oil on panel, central panel, 109 x 43 cm.
 Alte Pinakothek, Munich;
 side panels c63 x c46 cm.
 Gemäldegalerie Alte Meister, Dresden

14 Portrait of Dürer's Father at 70
 1497. Oil on panel, 51 x 40 cm.
 National Gallery, London

15 Self-portrait at 26
 1498. Oil on panel, 52 x 41 cm.
 Museo Nacional del Prado, Madrid

16 Lot Fleeing with his Daughters from
 Sodom
 c1498. Oil and tempera on panel, 52 x 41 cm.
 National Gallery of Art, Washington DC

17 Portrait of Oswolt Krel
 1499. Oil on panel, central panel 50 x 39 cm,
 side panels 50 x 16 cm. Alte Pinakothek, Munich

18 Portrait of Elsbeth Tucher
 1499. Oil on panel, 29 x 23 cm.
 Staatliche Kunstsammlungen, Kassel

19 Self-portrait at 28
 1500. Oil on panel, 67 x 49 cm.
 Alte Pinakothek, Munich

20 Nuremberg Woman Dressed for Church
 1500. Pen and ink and watercolour on paper,
 32 x 21 cm. Graphische Sammlung Albertina,
 Vienna

21 The Paumgartner Altarpiece
 c1498–1504. Oil on panel, central panel
 155 x 126 cm, side panels 157 x 61 cm.
 Alte Pinakothek, Munich

22 Lamentation for Christ
 c1500–3. Oil on panel, 151 x 121 cm.
 Alte Pinakothek, Munich

Text Illustrations

Comparative Figures

16 Portrait of Dürer's Mother
(attributed to Dürer)
*c*1490. Oil on panel, 47 x 36 cm.
Germanisches Nationalmuseum, Nuremberg

17 Studies of Self-portrait, Hand and Pillow
1493. Pen and ink on paper, 28 x 20 cm.
Metropolitan Museum of Art, New York

18 A Comet
(reverse of Plate 6)
*c*1495. Oil on panel, 23 x 17 cm.
National Gallery, London

19 A Lion
1494. Gouache on vellum, 13 x 17 cm.
Kunsthalle, Hamburg

20 The Madonna with the Monkey
*c*1498. Engraving, 19 x 12 cm.

21 Sky Study (reverse of Plate 10)
*c*1496. Black chalk with traces of watercolour,
26 x 37 cm. British Museum, London

22 Portrait of Frederick the Wise
1524. Engraving, 19 x 13 cm.

23 Study of a Man with a Drill
*c*1496. Pen and ink on paper, 25 x 15 cm.
Musée Bonnat, Bayonne

24 Virgin and Child at a Window
(reverse of Plate 16)
*c*1498. Oil and tempera on panel, 52 x 41 cm.
National Gallery of Art, Washington DC

25 Portrait of Hans Tucher
1499. Oil on panel, 28 x 24 cm.
Schlossmuseum, Weimar

26 Portrait of Felicitas Tucher
1499. Oil on panel, 28 x 24 cm.
Schlossmuseum, Weimar

27 Marriage of the Virgin
*c*1504. Woodcut, 29 x 21 cm.

28 Lamentation for Christ
*c*1497. Woodcut, 39 x 28 cm.

29 Study of a Parrot
*c*1502. Pen and ink and watercolour on paper,
19 x 21 cm.
Biblioteca Ambrosiana, Milan

30 St Joseph and St Joachim
*c*1503–4. Oil on panel, 96 x 54 cm.
Alte Pinakothek, Munich;

St Simeon and St Lazarus
*c*1503–4. Oil on panel, 97 x 55 cm.
Alte Pinakothek, Munich

31 Study of an Architect
1506. Brush and ink heightened with white on
paper, 39 x 26 cm.
Kupferstichkabinett, Berlin

32 Study of the Hands of the Young Christ
1506. Pen and ink heightened with white on paper,
21 x 19 cm.
Germanisches Nationalmuseum, Nuremberg

33 Adam and Eve
1504. Engraving, 25 x 19 cm.

34 The Martyrdom of the Ten Thousand
1497–8. Woodcut, 39 x 28 cm.

35 Design for the Landauer Altarpiece
1508. Pen and ink and watercolour on paper,
39 x 26 cm.
Musée Condé, Chantilly

36 Study of Emperor Charlemagne and
Emperor Sigismund
*c*1510. Pen and ink and watercolour on paper,
18 x 21 cm. Courtauld Institute Galleries, London

37 Apostle James
1516. Tempera on canvas, 46 x 38 cm.
Galleria degli Uffizi, Florence

38 Portrait of Maximilian I
1518. Charcoal and coloured chalk on paper,
38 x 32 cm. Graphische Sammlung Albertina,
Vienna

39 Study of St Anne
1519. Brush and ink heightened with white on
paper, 40 x 29 cm. Graphische Sammlung
Albertina, Vienna

40 Study of a Man Aged 93
1521. Brush and pen and ink heightened with
white on paper, 42 x 28 cm.
Graphische Sammlung Albertina, Vienna

1 Saint John's Church

*c*1489. Watercolour and gouache on paper, 29 x 42 cm. Formerly Kunsthalle, Bremen (temporarily Hermitage, St Petersburg)

This watercolour is among the earliest landscape paintings in European art to depict a specific location. Dürer may well have painted it in the summer of 1489, at the age of 18, although it could date from 1494 after his journeyman travels. Inscribed 'Saint John's Church', it shows the church and a row of houses which lay just to the west of Nuremberg. Nearly 40 years later Dürer was to be buried in Saint John's graveyard. Dürer's watercolour view faces south, with a view of the distant hills beyond. The perspective is curious; it is almost a bird's-eye view. The row of houses appears flat rather than three-dimensional. Despite these problems, Dürer has lavished great care on the picture. In his early watercolours he was more concerned about the rendering of detail, rather than the overall effect.

The watercolour of *Saint John's Church* was looted during the Second World War and lost for nearly 50 years. Owned by the Kunsthalle in Bremen, it was among thousands of Old Master drawings which had been hidden for safekeeping in the cellar of a mansion 50 miles north-west of Berlin. The Red Army occupied the house in 1945 and soldiers ransacked the art works. Viktor Baldin, a young officer, found this watercolour on the floor, among a mass of works abandoned by the first looters. He saved the picture, along with 363 other drawings (including *22 Dürers*), and brought it back to Russia. Baldin later gave the drawings to the architectural museum near Moscow where he worked. The existence of the missing Bremen pictures was kept secret until 1992. They are temporarily at the Hermitage in St Petersburg and lengthy negotiations are likely before their return to Bremen.

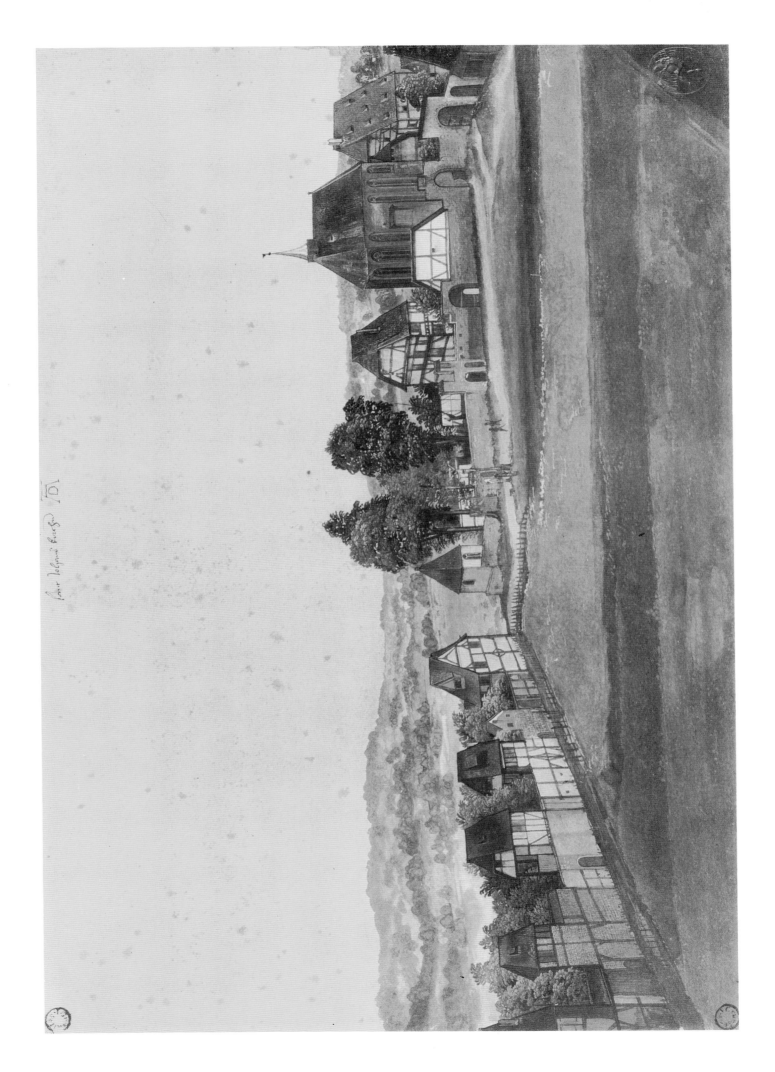

2 The Wire-drawing Mill

c1489. Watercolour and gouache on paper, 29 x 43 cm. Kupferstichkabinett, Berlin

Along with *Saint John's Church* (Plate 1), this is among Dürer's earliest watercolours, dating either from 1489 or 1494. Inscribed 'wire-drawing mill', it depicts a workshop which manufactured copper wire. The buildings in the foreground are the Grossweiden Mill on the north bank of the River Pegnitz, near St John's Church. A mill wheel leans against one of the buildings. On the far side of the river is the Kleinweiden Mill. Beyond this are villages lying on the outskirts of Nuremberg and the mountains. Dürer has again lavished great care on some of the details, such as the distant houses. His colouring is reminiscent of Netherlandish landscapes, with brown tones in the foreground, greens in the middle ground and bluish mountains in the distance.

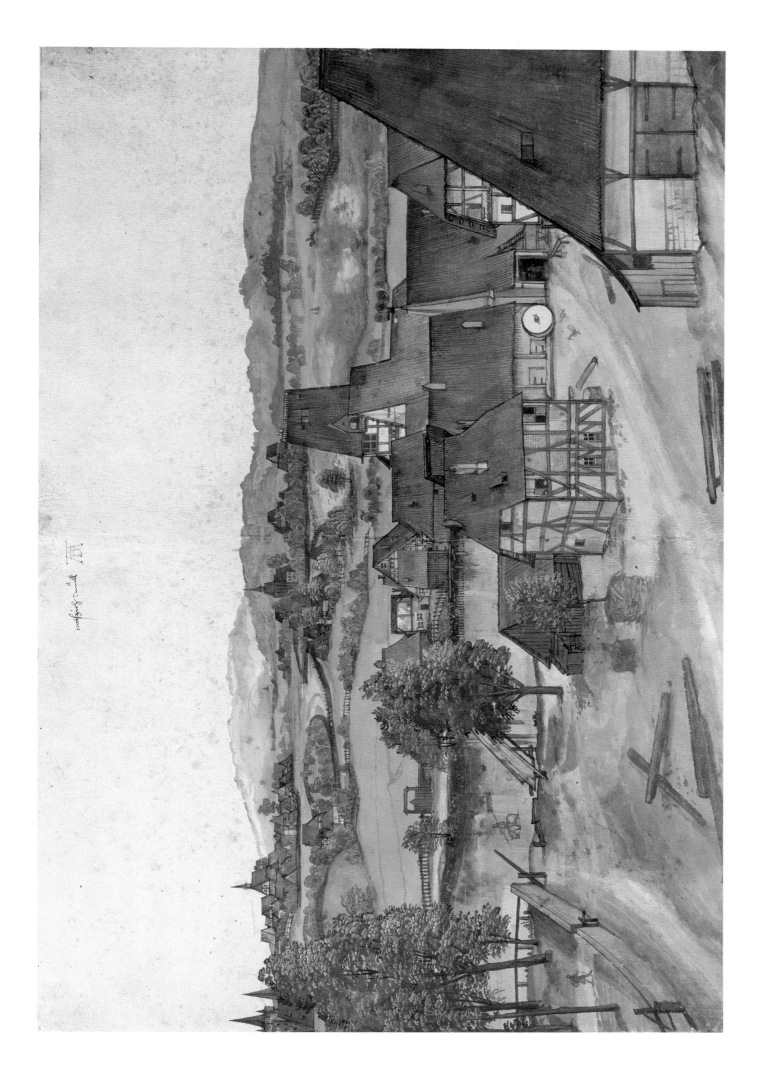

1490. Oil on panel, 48 x 40 cm. Galleria degli Uffizi, Florence

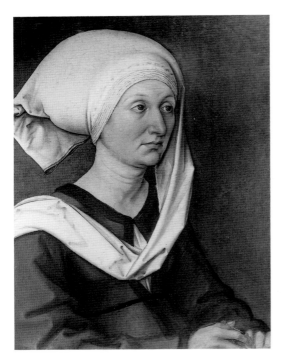

Fig. 16
Portrait of Dürer's
Mother (attributed to
Dürer)
*c*1490. Oil on panel, 47 x
36 cm.
Germanisches
Nationalmuseum,
Nuremberg

Dürer's earliest surviving oil painting, done just after he finished his apprenticeship, is a portrait of his father, the goldsmith Albrecht the Elder (1427–1502). Dated 1490, it was painted early in the year, before Dürer left Nuremberg on his journeyman travels in April. Albrecht the Elder, then probably aged 62 (or 63 if he was born at the beginning of 1427), is depicted from the waist up, wearing a black hat and brown cape lined with black fur. He holds a rosary. Dürer later wrote that his father 'lived an honourable, Christian life, was a man patient of spirit, mild and peaceable to all, and very thankful towards God'.

On the reverse of this portrait are the coats of arms of Albrecht the Elder and those of his wife Barbara Holper. The family name 'Dürer' originated from the name of the birthplace of Albrecht the Elder's father, since the village of Ajtó where he came from means 'door' in Hungarian and this was translated into German as 'Türe' or 'Düre'. The Dürer coat of arms therefore bears an emblematic, open double-door. The portrait of Albrecht the Elder may well have been the right wing of a diptych, with the other panel portraying his wife. A portrait believed to be of Barbara Holper (see Fig. 16), still in Nuremberg and attributed to Dürer, could well be the other half of the diptych, although it may be an early copy of a lost original.

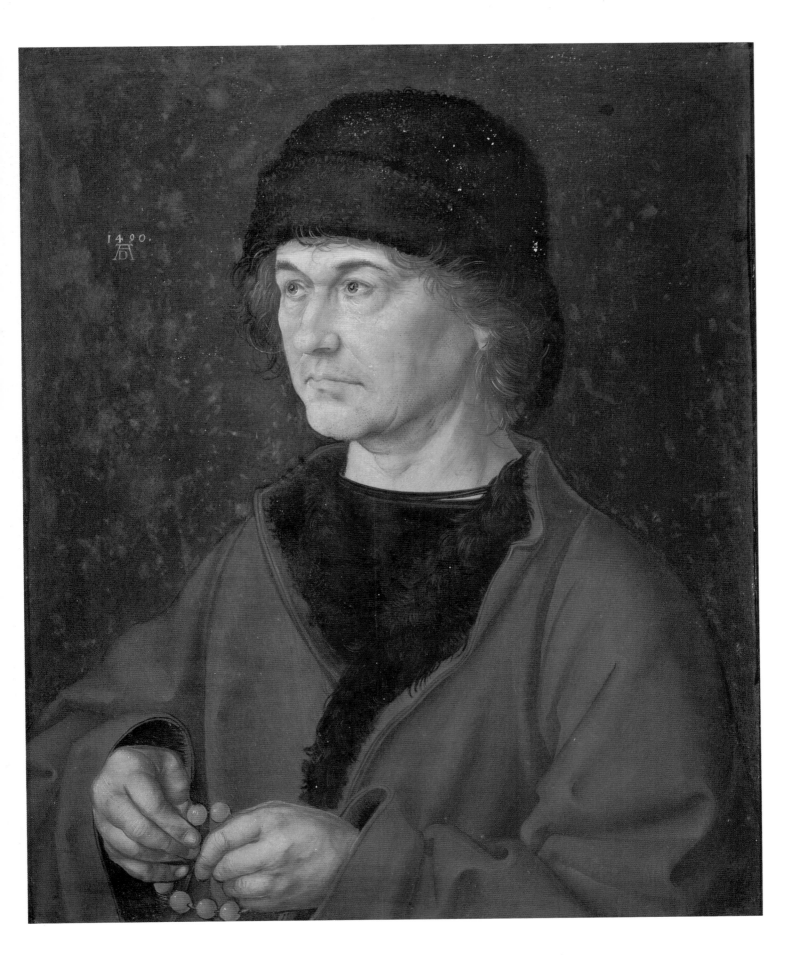

Self-portrait at 22

1493. Oil on linen, transferred from vellum, 57 x 45 cm. Musée du Louvre, Paris

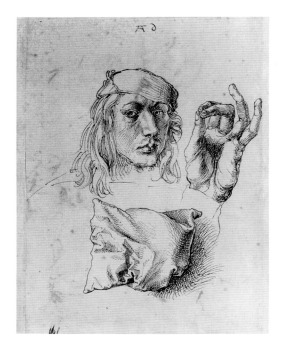

Fig. 17
Studies of Self-
portrait, Hand and
Pillow
1493. Pen and ink on
paper, 28 x 20 cm.
Metropolitan Museum of
Art, New York

This is Dürer's first painted self-portrait, dated 1493. It is the earliest known self-portrait in European art produced as an independent painting (although earlier artists had sometimes portrayed themselves among figures in an altarpiece or fresco). A sketched self-portrait, dated 1493 on the reverse, could well have been an early study for the oil painting (see Fig. 17). Dürer completed the oil painting towards the end of his travels as a journeyman, almost certainly in Strasbourg. It was originally on vellum, which would have made it relatively simple to transport, and this suggests that it might well have been sent back to Nuremberg.

Dürer inscribed at the top of the self-portrait: 'Things with me fare as ordained from above', a sign of his faith in God. The artist's youthful features are framed by his lanky, ginger hair, which is topped by a red tasselled cap. Beneath his grey cloak, fringed with red, he wears an elegant pleated shirt with pink ribbons. His strong nose, heart-shaped upper lip and long neck are emphasized in the painting. Using a mirror, Dürer obviously found it difficult to paint his hands and eyes, the two features which are always a challenge in a self-portrait.

In his rough hands, Dürer holds a sprig of sea holly, a thistle-like plant. Its German name means 'man's fidelity' and this, together with the fact that the plant was sometimes regarded as an aphrodisiac, has led to speculation that the self-portrait was intended as a gift for his fiancée. While Dürer was away, his father had arranged for Agnes Frey to become his wife and they eventually married on 7 July 1494, two months after his return to Nuremberg. However, it is just as likely that the self-portrait was a gift for his parents, whom he had not seen for nearly four years. One can imagine the surprise and pleasure they must have felt to receive this picture after their son's long absence. It would have been a reminder of his handsome features and further evidence of his blossoming talent.

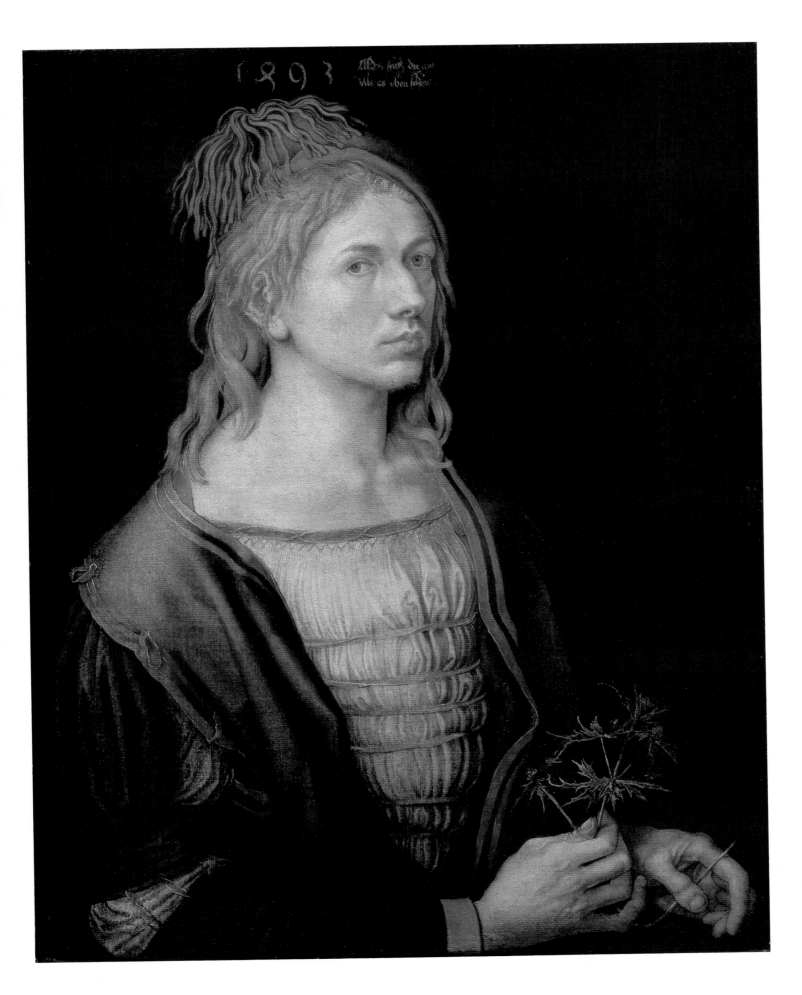

5 Christ as the Man of Sorrows

*c*1493. Oil on panel, 30 x 19 cm. Staatliche Kunsthalle, Karlsruhe

This work depicts Jesus after he had been scourged and mocked by the soldiers, just before he was led away to be crucified. Jesus bleeds profusely from his wounds and he holds the instruments used to beat him, a three-knotted whip and bundle of birches. He wears the crown of thorns, leaning his head on his right hand in a gesture of grief. His other hand rests on a ledge, a pose which Dürer often used to add a sense of depth to a portrait. The face is painted with great realism. Set against a gold background, Christ stares out of the picture, expressing resignation at his fate.

This devotional panel was identified as a Dürer in 1941 and although unsigned it is now widely accepted as a work by the young artist. It dates from his journeyman days and may well have been done in Strasbourg, probably in 1493 or early in 1494.

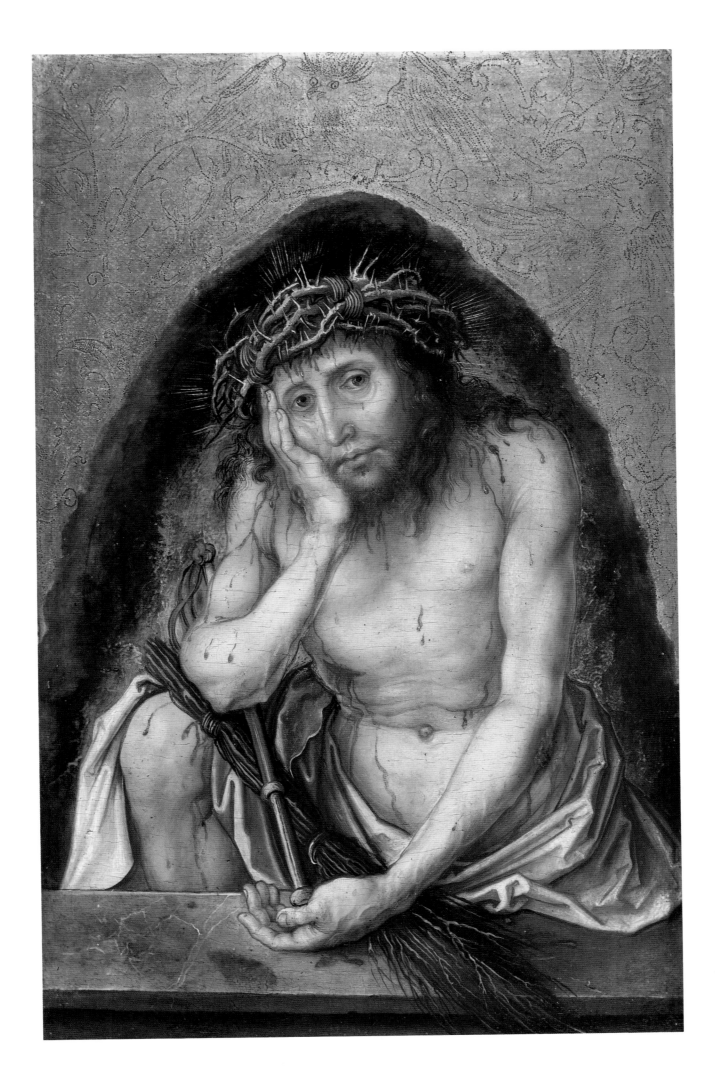

St Jerome in the Wilderness

*c*1495. Oil on panel, 23 x 17 cm. National Gallery, London

Fig. 18
A Comet (reverse of
Plate 6)
*c*1495. Oil on panel,
23 x 17 cm. National
Gallery, London

St Jerome kneels as a penitent. In his right hand he holds the Bible, which he translated into Latin, and in his left hand the stone which he is using to beat his breast. His eyes stare upwards, beyond the small crucifix stuck into the tree trunk. Wearing a blue gown, his red mantle and cardinal's hat lie beside him on the ground. Behind is his faithful lion, befriended after he had removed a thorn from its paw. In the background is a landscape with dramatic rock formations, probably based on sketches that Dürer had made of the quarries near Nuremberg. The scene is lit by a dramatic evening sky.

The reverse of the panel depicts an apocalyptic celestial phenomenon, a red star-like light and a streaking golden disc (see Fig. 18). Although some scholars have considered it to be an eclipse or meteor, it is almost certainly a comet. Dürer's image is probably derived from woodcuts of comets published in the *Nuremberg Chronicle* of 1493. A similar object to the one painted by Dürer appears in the sky of his engraving of *Melencolia I*, made 20 years later (see Fig. 12).

This small panel was only recognized as a Dürer in 1956. Art historian David Carritt realized that the lion is similar to that in a gouache which Dürer painted in Venice in 1494 (see Fig. 19). *St Jerome in the Wilderness* belonged to the Bacon family at Raveningham Hall, England, and in 1996 was acquired by the National Gallery.

Fig. 19
A Lion
1494. Gouache on vellum,
13 x 17 cm. Kunsthalle,
Hamburg

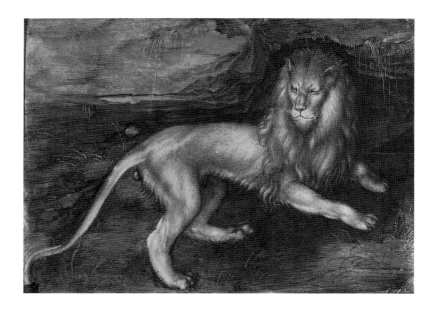

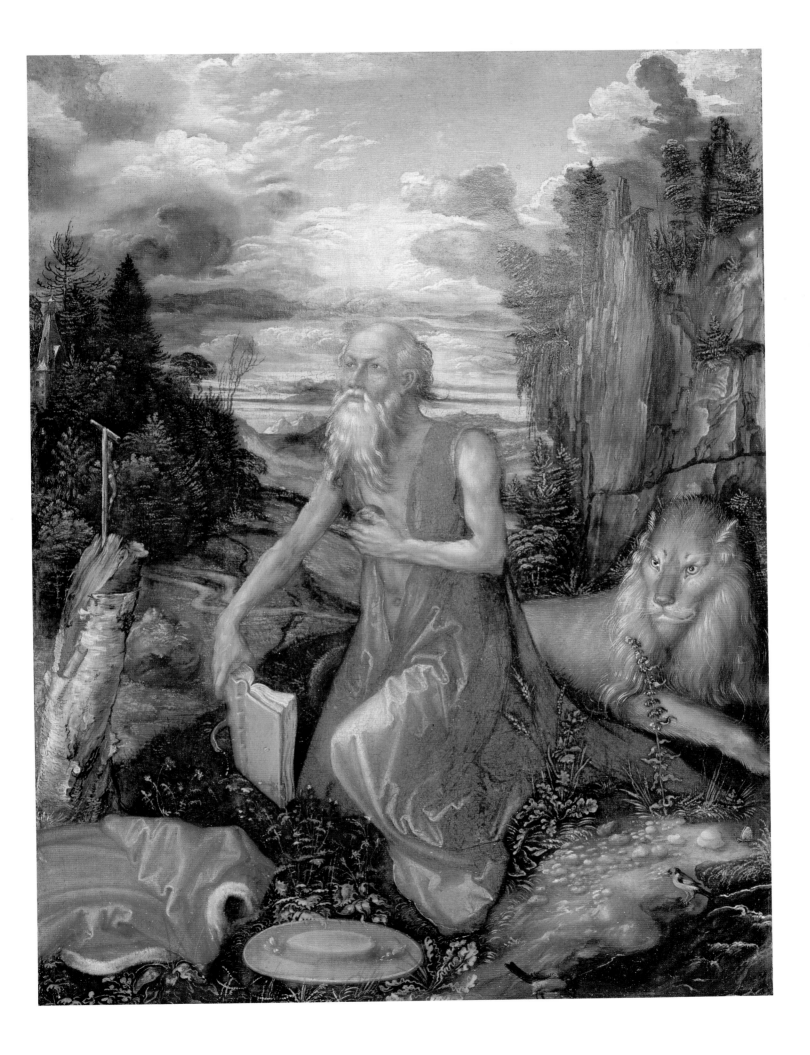

Virgin and Child before an Archway

*c*1495. Oil on panel, 48 x 36 cm. Fondazione Magnani-Rocca, Parma

The Virgin sits with the naked Christ child on her lap. The baby reaches for his mother's hand and their eyes meet. Although the figure of the Virgin is painted in the late-Gothic German tradition, the chubby infant is clearly influenced by Italian art. The picture dates either from Dürer's visit to Venice in 1494–5 or soon afterwards in Nuremberg. It was discovered in the 1950s in the Capuchin monastery of Bagnacavallo, near Ravenna, and this suggests that it was painted in Italy where it has remained.

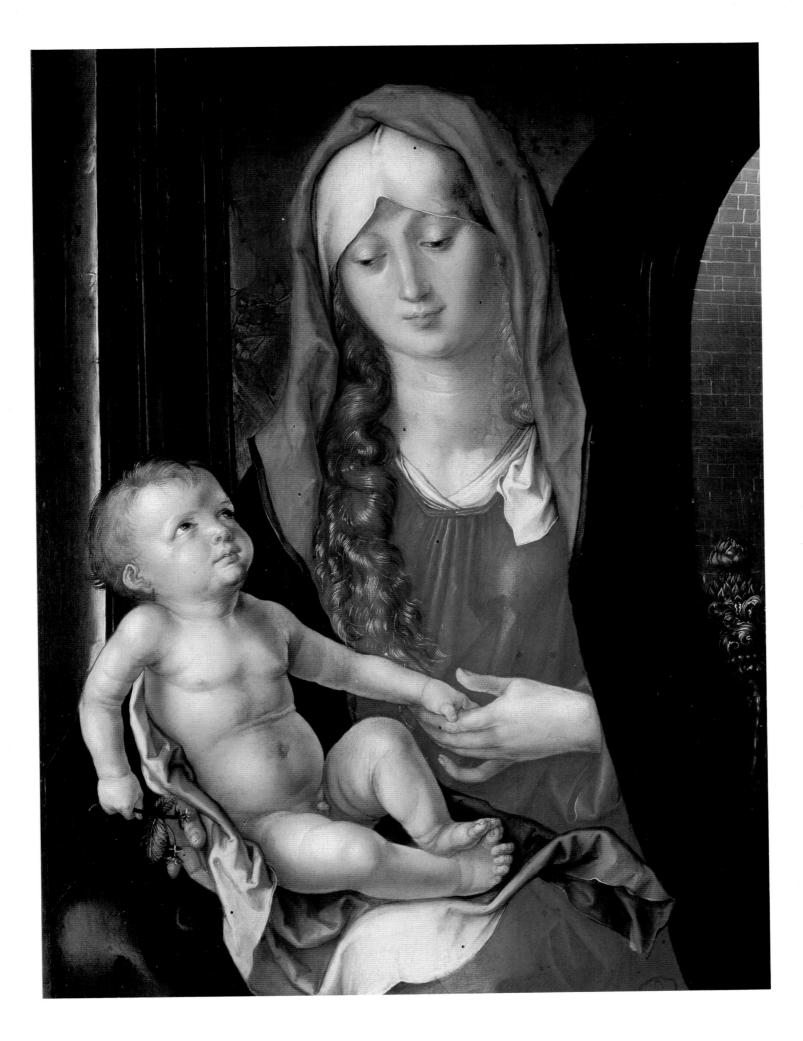

View of Arco

1495. Watercolour and gouache on paper, 22 x 22 cm. Cabinet des Dessins, Musée du Louvre, Paris

The Italian town of Arco nestles below a dramatic hilltop castle, near the northern shore of Lake Garda. This watercolour, incribed 'Venetian Outpost', was done on Dürer's return journey from Venice in 1495 and the vegetation suggests it is the late spring. Arco lies six miles west of the main route over the Alps, which runs north from Verona and over the Brenner Pass to Innsbruck.

Close to the sandy foreground is an olive grove and a vineyard. Beyond the vineyard, to the right, lies the walled town of Arco whose fortifications snake up the steep hillside to the twelfth-century castle. *View of Arco* is a very carefully arranged composition, created at the expense of a certain degree of topographical truth. The narrow section of sheer rock face on the far left of the composition could not have been seen from the spot where the view was painted. Dürer also omitted the mountains behind the fortified hill to increase the drama of the setting. The painting's delicate colours – greens, browns and greys – make it one of the artist's most successful watercolours.

One of the curiosities of *View of Arco* is the hidden image of a scowling man which can be seen on the left side of the hill. Running almost the entire height of the cliffs, the profile of the man's face looks leftwards and his pointed nose is particularly prominent. The rocks which compose his face are slightly lighter in tone than the surrounding cliffs, emphasizing the shape. Although initially it may be difficult to spot the hidden face, once seen it is unmistakable.

*c*1496. Watercolour and gouache on paper, 21 x 23 cm. British Museum, London

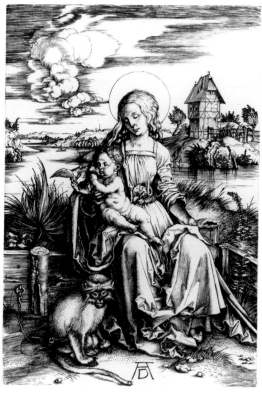

Fig. 20
The Madonna with
the Monkey
*c*1498. Engraving, 19 x 12 cm.

Dürer painted this watercolour soon after his return from Venice, probably in 1496. The site has been identified as a pond which was connected by a small canal to the River Pegnitz, near St John's Church on the outskirts of Nuremburg. The composition is based around the circular form of the pond, a shape echoed by the carefully-painted boat in the foreground. The dark threatening clouds of the evening sky contrast with the calm water and its reflections.

The watercolour is inscribed, 'House by a Pond'. The tall house, set on an island, probably served as a look-out post and a summer retreat in peacetime. Two years later Dürer depicted the same house, in reverse, in the background of his engraving of *The Madonna with the Monkey* (Fig. 20).

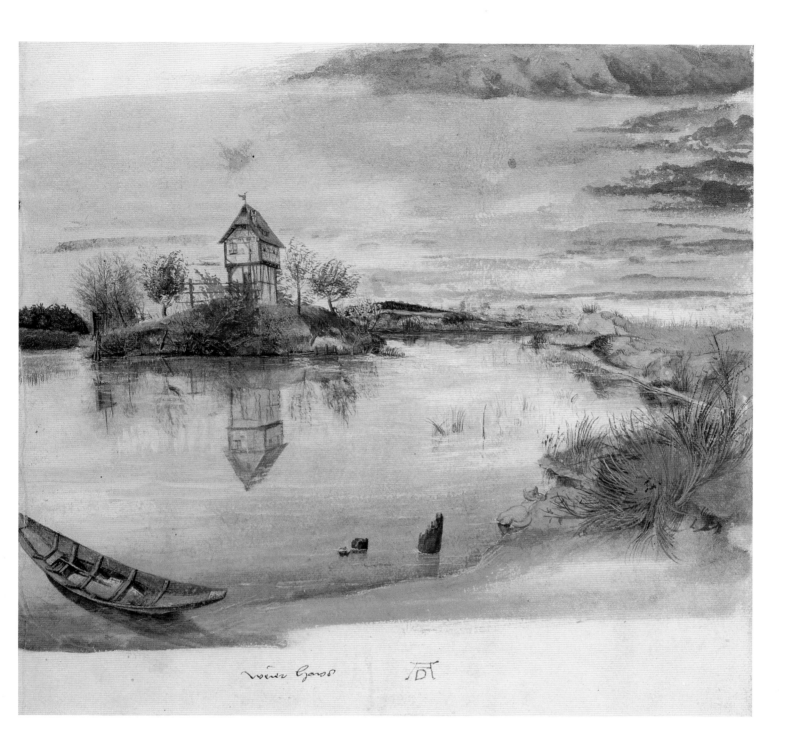

weier Gauss

Pond in the Woods

*c*1496. Watercolour and gouache on paper, 26 x 37 cm. British Museum, London

Dating from the same period as *House by a Pond* (Plate 9), this powerfully coloured watercolour depicts pine trees around a pond or lake, probably in the sandy heathland near Nuremberg. Although the tufts of grass in the foreground are rendered with painstaking detail, other parts of the picture have been left unfinished, particularly the sky and the greenery of the trees on the left. The water seems to stretch out far into the distance, changing colour from deep blue to a browny colour which reflects the evening sun. The powerful atmosphere is a vision of primeval nature.

A sketch, hidden for centuries, was recently discovered on the reverse of this work. It had been stuck into an album of drawings in 1637, which in 1753 was presented by Sir Hans Sloane to the newly-established British Museum. It was only in 1970 that the watercolour was removed from the album and the sketch was found on the reverse (see Fig. 21). Although Dürer seems to have abandoned this very rough sketch at an early stage, it appears to depict a similar evening sky to the one in the final watercolour.

Fig. 21
Sky Study (reverse of Plate 10)
*c*1496. Black chalk with traces of watercolour, 26 x 37 cm.
British Museum, London

11 Willow Mill

*c*1496–8. Watercolour and gouache on paper, 25 x 37 cm. Cabinet des Estampes,
Bibliothèque Nationale de France, Paris

Inscribed 'Willow Mill', the view is from the north bank of the River
Pegnitz, on the outskirts of Nuremberg. The buildings in the centre are
the Grossweiden Mill and across the bridge on the left is the Kleinweiden
Mill. This site appeared in Dürer's *The Wire-drawing Mill* (Plate 2), dating
from about eight years earlier. Comparing these two works demonstrates
the development of Dürer's landscapes during this period. In his early
works he placed a much greater emphasis on topography, with the scene
being recorded in painstaking detail. Here, although the buildings and the
large tree are treated in detail, the foreground and sky are lightly sketched.
In this watercolour, Dürer was primarily interested in capturing the atmo-
sphere of the stormy evening sky and the reflections in the water. This is
arguably Dürer's most accomplished watercolour landscape.

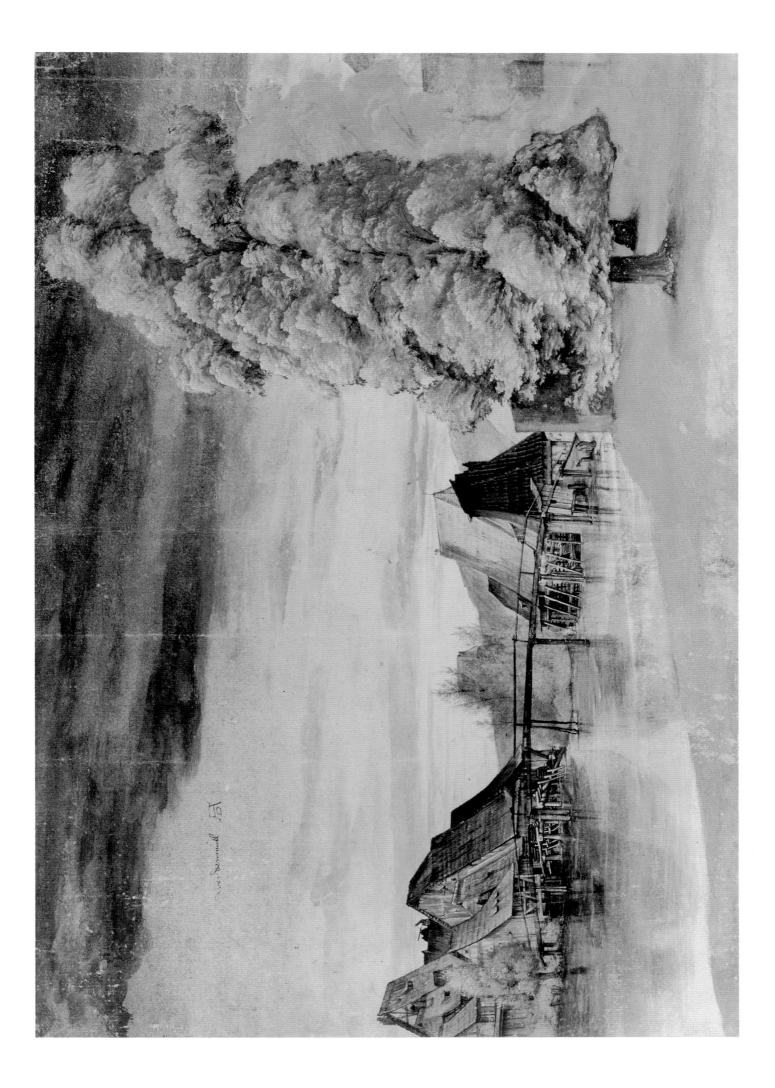

Portrait of Frederick the Wise

1496. Tempera on canvas, 76 x 57 cm. Staatliche Museen zu Berlin – Preussischer Kulturbesitz Gemäldegalerie, Berlin

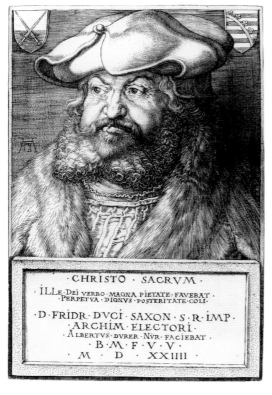

Fig. 22
Portrait of Frederick
the Wise
1524. Engraving, 19 x 13 cm.

Frederick III (1463–1525), known as Frederick the Wise, had became Elector of Saxony in 1486 and was one of the princes entitled to select the Holy Roman Emperor. He later became Dürer's first major patron. This portrait was probably done when Frederick the Wise visited Nuremburg from 14–18 April 1496. Dürer used quick-drying tempera paint, rather than oil paint, and this may have been so that the picture could be taken away. Frederick the Wise, then 33, is depicted from the waist up, elegantly dressed and set against a light-green background. His folded arms rest on a ledge and in his left hand he holds a small scroll. The monarch's slight frown is probably intended to convey fortitude. The most striking aspect of the portrait are Frederick's piercing eyes, staring straight at the viewer.

Frederick the Wise must have been pleased with this portrait as Dürer was then commissioned to paint a series of important altarpieces for the church at the Elector's palace in Wittenberg. Dürer sketched Frederick the Wise 27 years later as an elderly statesman and the following year the drawing was used for an engraving (see Fig. 22).

The Seven Sorrows of the Virgin

*c*1496–7. Oil on panel, central panel, 109 x 43 cm. Alte Pinakothek, Munich; side panels *c*63 x *c*46 cm. Gemäldegalerie Alte Meister, Dresden

Fig. 23
Study of a Man with a
Drill
*c*1496. Pen and ink on
paper, 25 x 15 cm.
Musée Bonnat, Bayonne

Dürer's earliest known altarpiece may well have been commissioned by Frederick the Wise for his palace church at Wittenberg. It was probably ordered in April 1496, when Dürer painted his portrait (see Plate 12). A payment of 100 florins was made to the artist at the end of the year for the altarpiece.

The altarpiece was originally very large, nearly two metres high and nearly three metres wide. The right half, representing the Seven Joys of the Virgin, is now missing and only the left half of the Seven Sorrows survives. The central part of the surviving wing depicts the grieving Virgin after the Crucifixion, with a golden sword about to pierce her heart. Around the Virgin are seven smaller panels with detailed scenes from the life of Christ (anticlockwise from top left): the Circumcision, the Flight into Egypt, the 12 year-old Christ among the Doctors, the Bearing of the Cross, the Nailing to the Cross, the Crucifixion and the Lamentation.

The altarpiece was made in Dürer's newly established workshop and although it was made to his design, some of it may have been painted by assistants. Dürer's pen and ink study survives of the man drilling a hole in the Cross in the lower right panel of the Nailing to the Cross (see Fig. 23).

The whole altarpiece was acquired in the mid-sixteenth century by the artist Lucas Cranach the Younger (1515–86), whose distinguished father had served as court painter in Wittenberg. It was probably Cranach the Younger who sawed the work into separate panels. The panel of the grieving Virgin (which at some point was reduced in size by 18 centimetres at the top) is now in Munich and those of the Seven Sorrows are in Dresden. The right half of the altarpiece representing the Seven Joys is known only through copies.

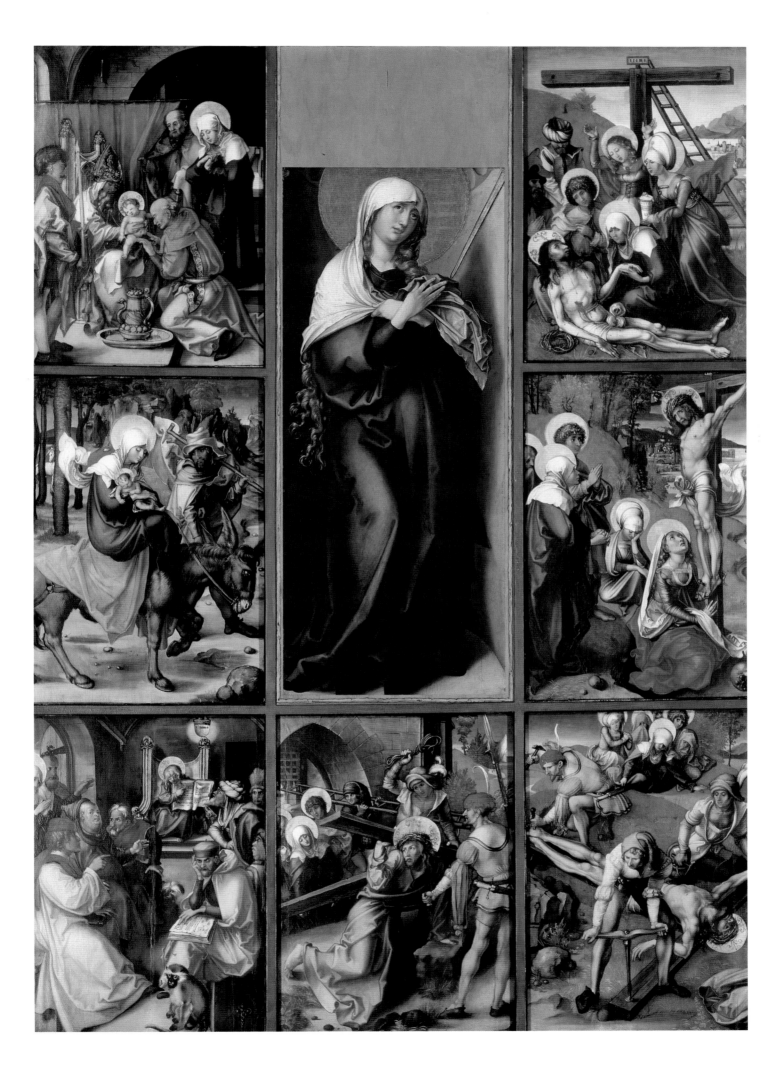

Portrait of Dürer's Father at 70

1497. Oil on panel, 51 x 40 cm. National Gallery, London

The portrait is inscribed '1497 Albrecht Dürer the Elder at age 70'. Dürer's father appears considerably older than in the portrait of seven years earlier (see Plate 3). His lips are thinner, his face more heavily lined with wrinkles and his narrow eyes have a wearier appearance. Yet Albrecht the Elder has retained his wisdom and dignity. After his death, Dürer wrote that his father 'passed his life in great toil and stern, hard labour...He underwent manifold afflictions, trials and adversities.' Albrecht the Elder died five years after this portrait was painted, at the age of 75.

The condition of this painting is poor, particularly in the background and the cloak, and in the past many scholars believed that it was a copy of a lost original. However, since it was cleaned in 1955, there has been more support for the view that this is indeed the original. Fortunately the face is the part of the picture which remains in the best condition.

This portrait may originally have been displayed with Dürer's self-portrait of the following year (see Plate 15), either hung in the same room in the family home or even linked as a diptych. Although Dürer and his father are wearing very different clothing and the backgrounds do not match, the two portraits are almost the same size and the half-length poses are similar. The pictures were apparently kept together as a pair, since they were presented by the city of Nuremberg to the Earl of Arundel in 1636 as a gift for Charles I of England. Both paintings were sold in 1650 by Cromwell. The portrait of Albrecht Dürer the Elder stayed in Britain and was eventually bought by the National Gallery in 1904.

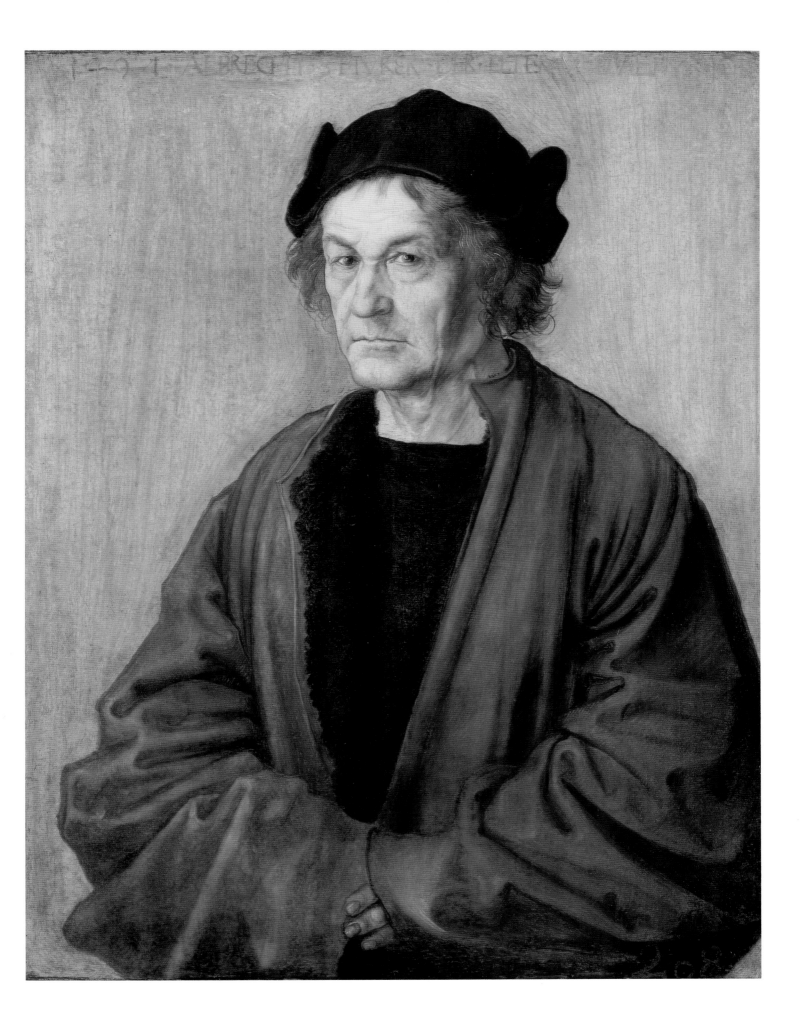

15 Self-portrait at 26

1498. Oil on panel, 52 x 41 cm. Museo Nacional del Prado, Madrid

This self-portrait is dated 1498 and inscribed: 'I have thus painted myself. I was 26 years old. Albrecht Dürer.' Since the artist turned 27 on the 21 May, the picture must date from the beginning of the year. The artist's pose is self-confident, showing him standing upright and turning slightly to lean his right arm on a ledge. Dürer's figure fills the picture, with his hat almost touching the top. His face and neck glow from the light streaming into the room and his long curly hair is painstakingly depicted. Unlike his earlier self-portrait (see Plate 4), he now has a proper beard, which was then unusual among young men. Nine years later Dürer wrote an ironic poem in which he described himself as 'the painter with the hairy beard'.

The artist's clothing is flamboyant. His elegant jacket is edged with black and beneath this he wears a white, pleated shirt, embroidered along the neckline. His jaunty hat is striped, to match the jacket. Over his left shoulder hangs a light-brown cloak, tied around his neck with a twisted cord. He wears fine kid gloves. By depicting himself in such glamorous attire, the youthful Dürer stresses the elevated social position which he believed artists deserved.

Inside the room is a tall archway, partly framing Dürer's head, and to the right a window opens out onto an exquisite landscape. Green fields give way to a tree-ringed lake and beyond are snow-capped mountains, probably a reminder of Dürer's journey over the Alps three years earlier. Depicting a distant landscape, viewed through a window, was a device borrowed from Netherlandish portraiture. This picture was acquired by Charles I of England and later bought by Philip IV of Spain.

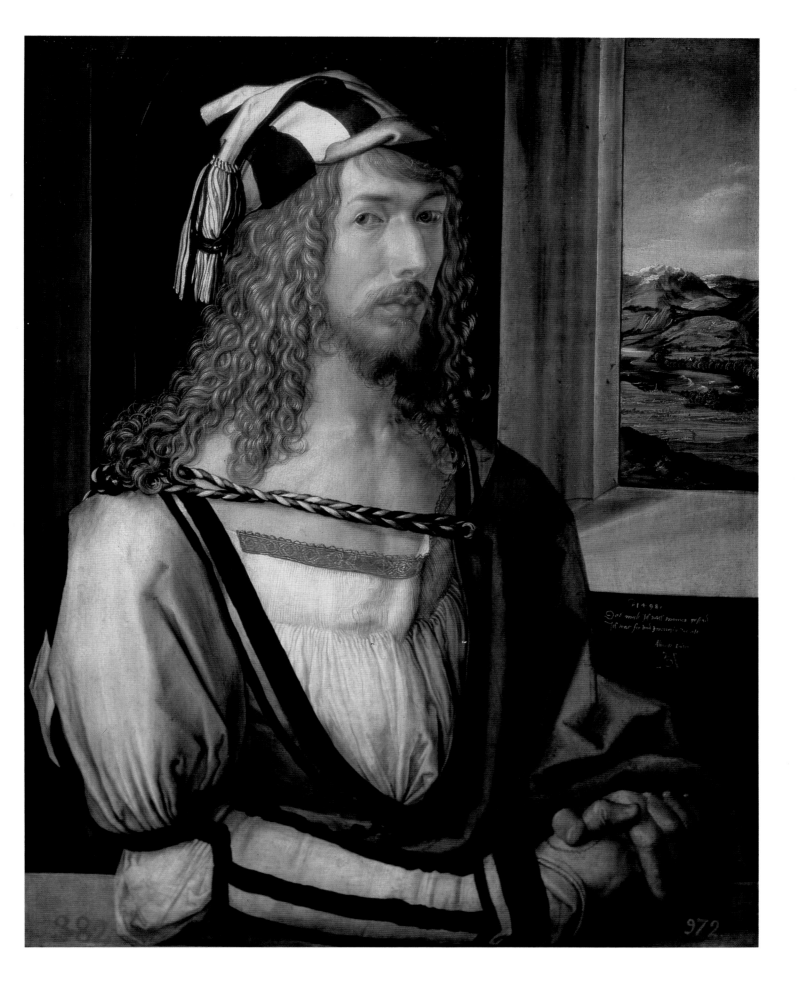

*c*1498. Oil and tempera on panel, 52 x 41 cm. National Gallery of Art, Washington DC

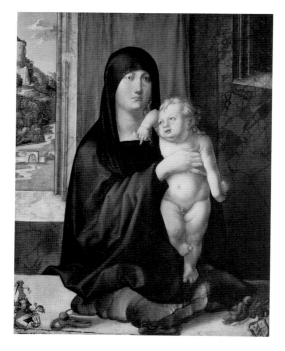

Fig. 24
Virgin and Child at a
Window (reverse of
Plate 16)
*c*1498. Oil and tempera on
panel, 52 x 41 cm.
National Gallery of Art,
Washington DC

This delightfully spontaneous panel depicts Lot and his two daughters fleeing from the destruction of Sodom. In the story from Genesis, two angels warn Lot that he should escape before God destroys the city for its sins. Lot is told that his family must not look back, otherwise they will be turned into pillars of salt.

In Dürer's panel, Lot leads the way, dressed in a warm fur-lined coat and a magnificent turban. He carries a basket of eggs and has a flask of wine slung over his shoulder on his stick. His two daughters follow several paces behind, one bearing a bundle on her head and the other with an elegant casket and a distaff and yarn. Far behind them, near the towering rocks, is Lot's wife, transformed into a brown pillar of salt. In the distance the town of Sodom explodes with brimstone and fire, huge columns of smoke belching up into the sky. Gomorrah, in the far distance, suffers a similar fate.

This depiction of Lot's flight is not the main picture, but the reverse of a panel of the Virgin and Child (see Fig. 24). The two sides are quite different, not only in subject-matter but also in style. The Lot panel is painted in a loose, spontaneous manner, whereas the Virgin and Child is much more finely worked. However, Dürer must have intended them to be seen together. The panel was painted for the Nuremberg merchant family of Haller, whose arms appear in the bottom left corner of the panel of the Virgin.

Virgin and Child at a Window was long assumed to be the work of the Venetian artist Giovanni Bellini, because of its composition and colouring. In 1934 it was identified as a Dürer, painted about three years after his return from Venice. It was bought by Baron Heinrich von Thyssen-Bornemisza, who owned it until 1950.

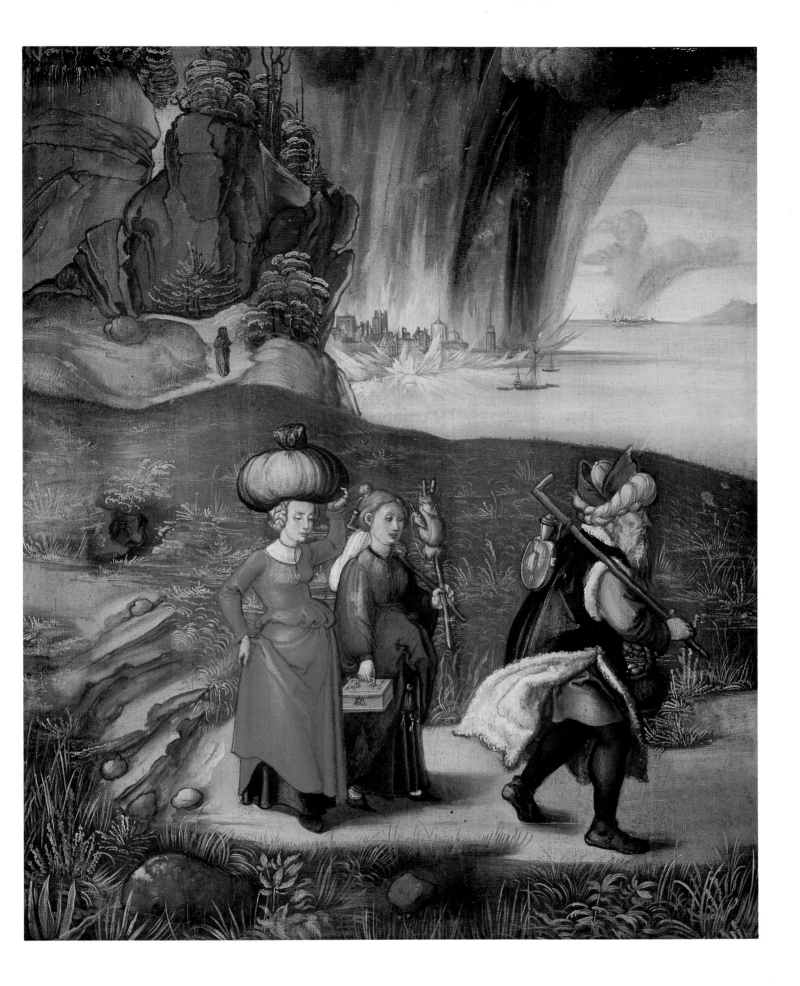

Portrait of Oswolt Krel

1499. Oil on panel, central panel 50 x 39 cm, side panels 50 x 16 cm. Alte Pinakothek, Munich

Oswolt Krel (d.1534) was a Lindau merchant and head of the Great Ravensburg Trading Company in Nuremberg between 1494 and 1503. In Dürer's portrait he appears to be in his late twenties. His angular face and strong nose is emphasized. The contrast between the angle of his body and the direction of his gaze suggests that he is turning round. Krel has an aggressive appearance, an effect strengthened by the piercing eyes and the strong red background. Dürer's depiction may well have been justified, since Krel had been imprisoned two years earlier for mocking a citizen during the Mardi Gras celebrations. On the left edge of the portrait is a strip of landscape, with a meandering stream flowing past a clump of tall slender trees.

The two smaller panels depict aggressive hair-covered wildmen brandishing clubs and holding coats of arms, those of Oswolt Krel (on the left) and his wife Agathe von Esendorf (on the right). They may originally have formed a cover for the portrait, but were later displayed as wings.

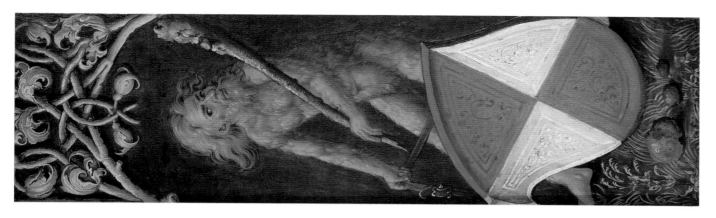

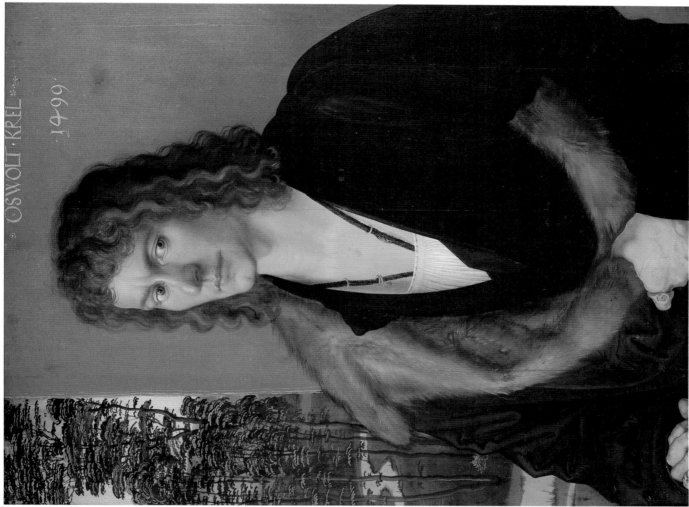

· OSWOLT · KREL ·

· 1499 ·

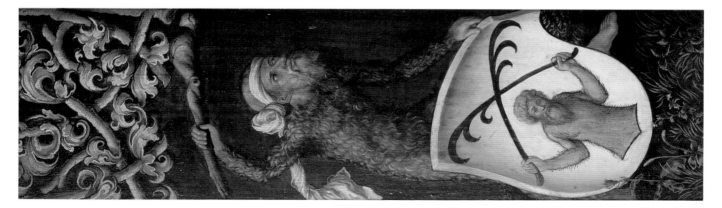

1499. Oil on panel, 29 x 23 cm. Staatliche Kunstsammlungen, Kassel

Elsbeth Tucher (née Pusch) is portrayed against an ornate brocade hanging. At the top of the panel is the inscription, 'Elsbeth Niclas Tucher at 26 years 1499'. This is the right wing of a diptych, but the left wing portraying her husband Niclas is missing. Elsbeth holds her wedding ring and the clasp of her blouse is formed with the initials NT, presumably a gift from her husband. The initials WW worked into her blouse and the mysterious letters MHIMNSK on the band over her voluminous headscarf have so far defied interpretation. Just visible on her shoulders is a gold necklace, evidence of her social standing. Above the parapet on the left of the panel is a landscape, with a wood-fringed lake leading to distant mountains, set beneath a stormy sky.

Dürer also painted matching portraits of the brother of Niclas, Hans Tucher and his wife Felicitas (née Rieter) (see Figs. 25 and 26). In this diptych, it is the husband who holds a ring and his wife a flower.

Fig. 25
Portrait of Hans
Tucher
1499. Oil on panel, 28 x 24 cm.
Schlossmuseum, Weimar

Fig. 26
Portrait of Felicitas
Tucher
1499. Oil on panel, 28 x 24 cm.
Schlossmuseum, Weimar

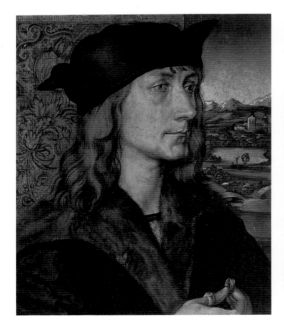
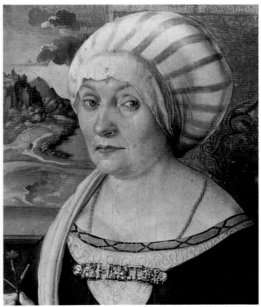

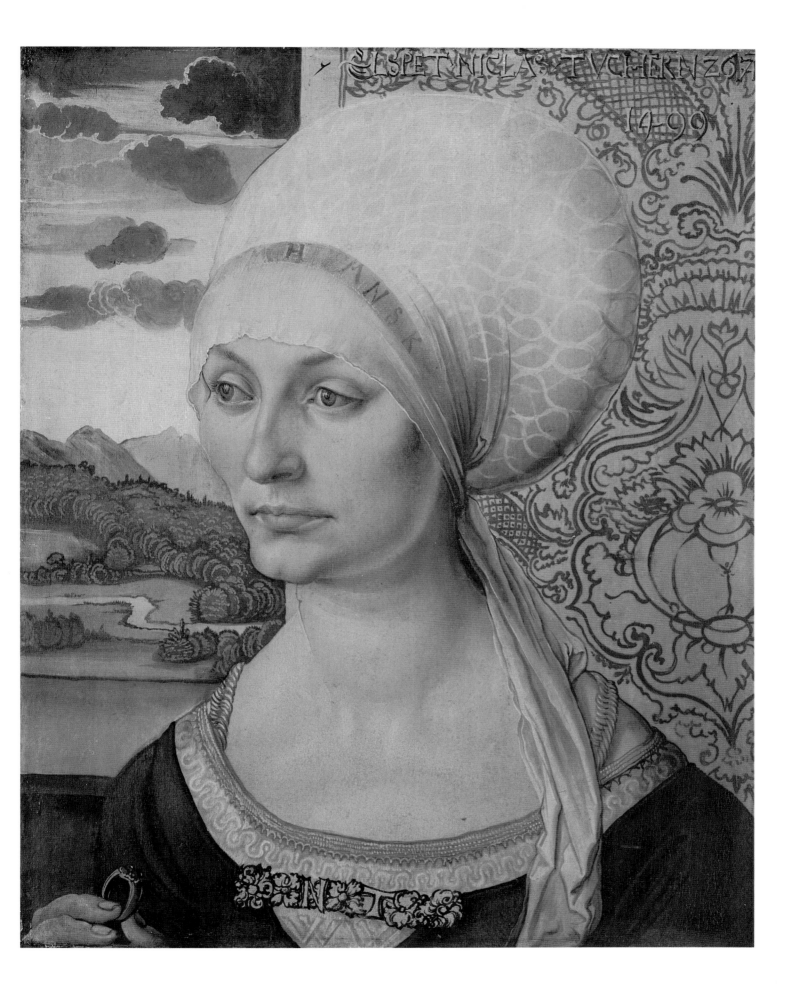

Self-portrait at 28

1500. Oil on panel, 67 x 49 cm. Alte Pinakothek, Munich

The last of Dürer's three magnificent self-portraits was painted early in 1500, before his 29th birthday on 21 May. The picture is proudly inscribed: 'Thus I, Albrecht Dürer from Nuremburg, painted myself with indelible colours at the age of 28 years.' It is a sombre image, painted primarily in browns, set against a plain dark background.

The face is striking for its resemblance to the head of Christ. In late medieval art, Jesus was traditionally presented in this manner, looking straight ahead in a symmetrical pose. Christ's brown hair in these images is parted towards the middle and falls over the shoulders. He has a short beard and moustache. Dürer has even painted himself with brown hair, although the other self-portraits show that it was actually reddish-blond. Dürer deliberately set out to create a Christ-like image, with his hand raised to his chest almost in a pose of blessing. But this was no gesture of arrogance or blasphemy. It was a statement of faith: Christ was the son of God and God had created Man. For Dürer, the painting was an acknowledgment that artistic skills were a God-given talent.

However, Dürer has subtly departed from the traditional image of Christ in his self-portrait. Despite initial appearances, the picture is not quite symmetrical. The head lies just off the centre of the panel to the right and the parting of the hair is not exactly in the middle, with the strands of hair falling a little differently on the two sides. The eyes stare slightly towards the left of the panel. Dürer also wears contemporary clothing, a fashionable fur-lined mantle. The result is a highly personal image, one whose 'indelible colours' still influence the way we imagine Dürer looked in his later years.

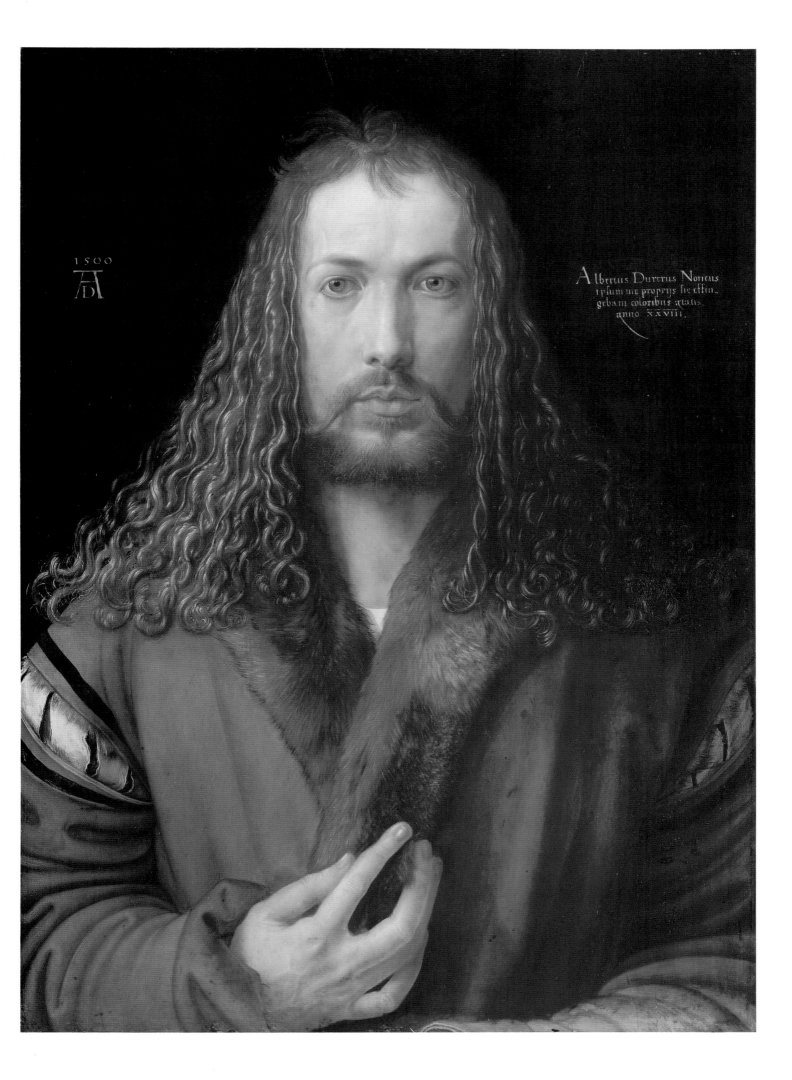

1500. Pen and ink and watercolour on paper, 32 x 21 cm. Graphische Sammlung Albertina, Vienna

Fig. 27
Marriage of the Virgin
*c*1504. Woodcut, 29 x 21 cm.

Dürer, who seems to have dressed well himself, was always interested in depicting clothing and he produced some of the earliest known costume studies in European art. This is one of a set of four costume studies of Nuremberg women, two of them in dancing dresses and one in everyday attire. The artist's wife Agnes, then in her mid-twenties, was probably the model.

The watercolour is inscribed: 'This is how people dress for church in Nuremberg' along with the text 'Think of me in Thy Realm'. Dressed in her best clothes for church, the demure young woman wears a red cloak with a green lining and beneath this is a blue-green dress fringed with white fur. She has a starched linen head-dress. Her eyes look down at the ground, in a contemplative pose. Four years later Dürer used this study in his woodcut of the *Marriage of the Virgin* (Fig. 27). The Nuremberg woman appears at the right of the print, in reverse, as one of the seven virgins who were Mary's companions.

*c*1498–1504. Oil on panel, central panel 155 x 126 cm, side panels 157 x 61 cm. Alte Pinakothek, Munich

This triptych was commissioned by the brothers Stephan and Lukas Paumgartner for St Catherine's Church in Nuremberg. It may well have been ordered after Stephan's safe return from a pilgrimage to Jerusalem in 1498. The main panel depicts the Nativity, set in an architectural ruin. The left wing shows St George with a fearsome dragon and the right wing St Eustace, with both saints dressed as knights and holding identifying banners. A seventeenth-century manuscript records that the side panels were painted in 1498 and that the two saints were given the features of the Paumgartner brothers (with Stephan on the left and Lukas on the right). This is the earliest occasion on which an artist is known to have used the facial features of a donor in depicting a saint. The exteriors of the wing panels were of the Annunciation, although only the figure of the Virgin on the left panel has survived.

On stylistic grounds, the Nativity was painted a few years later than the wings, probably in 1502 or soon afterwards. The tiny body of Christ is almost lost in the composition, surrounded by a swarm of little angels. Peering out from behind the Romanesque columns on the right are the ox and the ass, while opposite them on the left side are the faces of two shepherds. The composition, formed by the ruins of a palatial building, draws the eye towards the archway. Two other shepherds step up into the courtyard, the red and blue of their clothes echoing the colours of Joseph and the Virgin Mary. In the sky, an angel descends to reveal news of Christ's birth to another pair of shepherds tending their flock on the distant hillside. Although traditionally a night-time scene, it is brightly illuminated by a ball of light in the sky.

The small figures at the bottom corners of the central panel are the Paumgartner family with their coats of arms. They were painted over in the seventeenth century, when donor portraits went out of favour, and were only uncovered during restoration in 1903. On the left behind Joseph are the male members of the family, Martin Paumgartner, followed by his two sons Lukas and Stephan and an elderly bearded figure who may be Hans Schönbach, second husband of Barbara Paumgartner. On the far right is Barbara Paumgartner (née Volckamer), with her daughters Maria and Barbara.

In 1988 this painting was seriously damaged by a vandal, along with the *Lamentation for Christ* (Plate 22) and the central panel of *The Seven Sorrows of the Virgin* (Plate 13) depicting the grieving Mary. Restoration of the *Paumgartner Altarpiece* and the *Lamentation for Christ* was completed in 1998 and work then began on the panel of the Virgin.

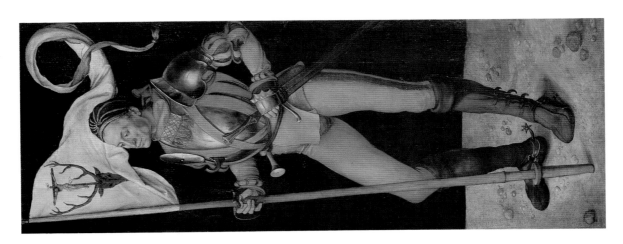

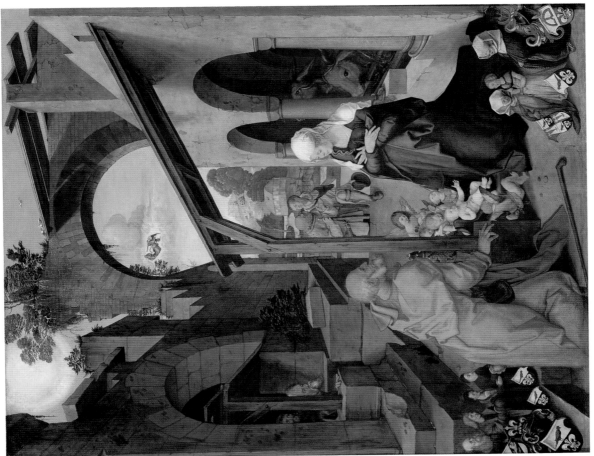

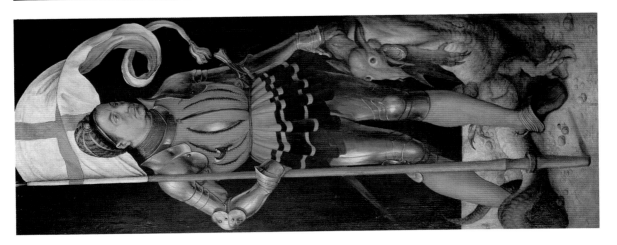

Lamentation for Christ

c1500–3. Oil on panel, 151 x 121 cm. Alte Pinakothek, Munich

Fig. 28
Lamentation for Christ
c1497. Woodcut, 39 x 28 cm

This altarpiece was donated to Nuremberg's Dominican church by the goldsmith Albrecht Glim, who is depicted as a small figure (now in faded brown) in the lower left corner with his two sons. It was probably commissioned in memory of the death of his first wife Margareth (née Holtzmann) in 1500, who kneels in the lower right corner with her daughter. The figures of the donors were overpainted in the early seventeenth century and subsequently exposed in 1924.

The scene shows the body of the dead Christ, just after it had been brought down from the Cross. The Virgin Mary, in the centre of the composition, clasps her hands in grief. John the Evangelist stands at the top of the pyramid of mourners. The upright section of the Cross pierces the sky. In the distance a magnificent city rises on a hill, a Gothic version of Jerusalem. Further away a series of mountain ranges rises from the sea, set beneath a dark, stormy sky.

This composition of the Lamentation, which had been developed in the Netherlands, was introduced into German art by Dürer. Several years earlier he had done a woodcut of the Lamentation as part of 'The Large Passion' series of woodcuts (see Fig. 28). Another painting of the Lamentation (Germanisches Nationalmuseum, Nuremberg), probably done by Dürer's workshop, was commissioned in 1498 in memory of Karl Holzschuher.

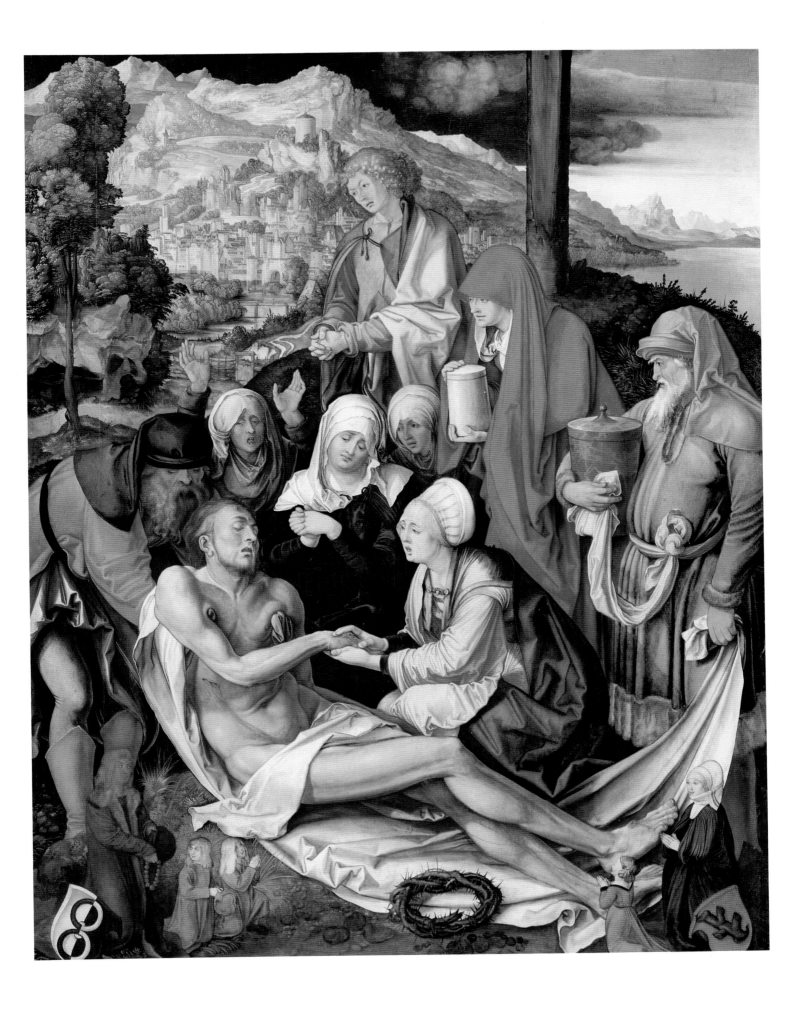

23 A Young Hare

1502. Watercolour and gouache on paper, 25 x 23 cm. Graphische Sammlung Albertina, Vienna

Dürer was one of the earliest artists to tackle nature studies and this is one of his finest examples. The frightened hare has cowered down with its ears alert, ready to spring up and flee. Dürer probably painted the hare from both a stuffed model and very careful observation of live animals.

A Young Hare was first painted in watercolour. Dürer then applied some opaque gouache on top of the watercolour, painting groups of lines which are longer or shorter, thicker or finer, depending on how the fur lies on the animal's body. Finally, he added the white highlights. The shadow helps to give the animal a three-dimensional appearance. Dürer added his monogram and the year in a prominent position, to show that he regarded it as a finished work of art.

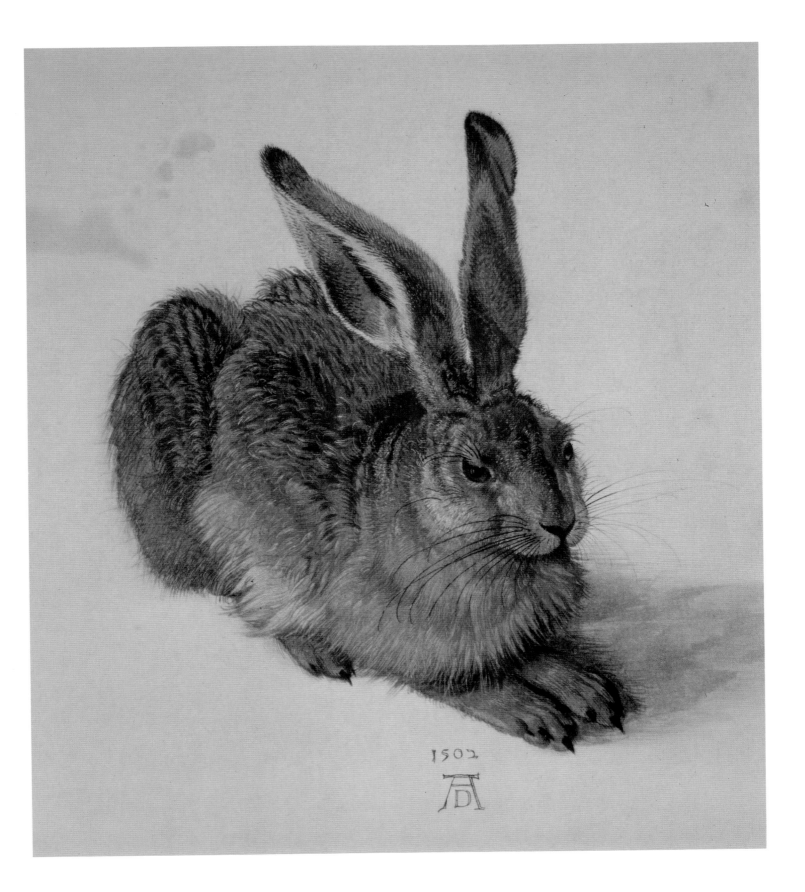

The Large Turf

1503. Watercolour and gouache on paper, 41 x 32 cm. Graphische Sammlung Albertina, Vienna

Dürer took an apparently insignificant piece of nature and produced a magnificent work of art. Although at first sight it appears to be a random fragment of a springtime meadow, the composition is carefully arranged and the grasses are seen from a low angle, very close to ground level. Growing out of the damp earth at the front, possibly in a swamp, are a few strands of fine grass, behind which are several greater plantain with their large oval leaves. Further away are three dandelions, their flowers closed up, and then more grass. Although a careful examination reveals the different species, one is left with the effect of the whole of a section of turf, rather than the individual plants. Dürer painted another work known as *The Small Turf* (Graphische Sammlung Albertina, Vienna) and hence the name of the present watercolour.

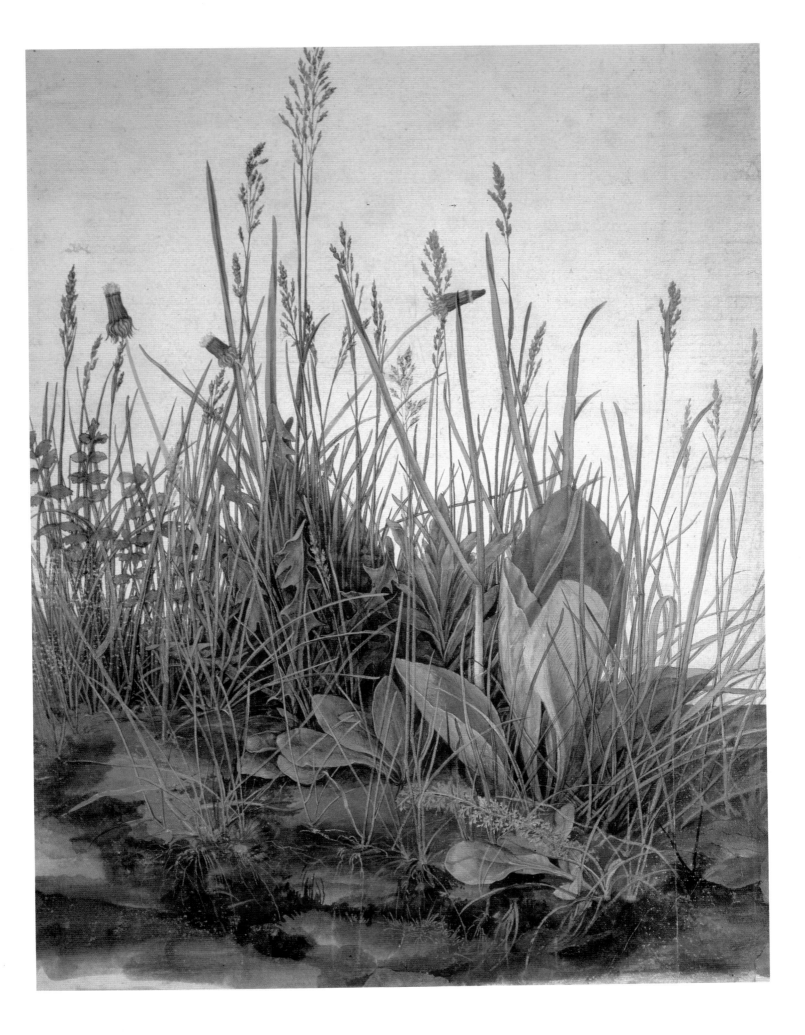

1503. Pen and ink and watercolour on paper, 32 x 24 cm. Graphische Sammlung Albertina, Vienna

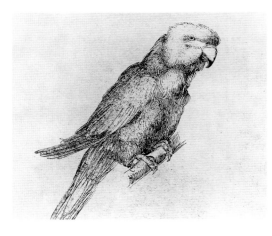

Fig. 29
Study of a Parrot
c1502. Pen and ink and
watercolour on paper,
19 x 21 cm.
Biblioteca Ambrosiana,
Milan

The Virgin holds the Christ child, who ignores the natural wonders around him and points towards Joseph. The small figure of Joseph stands near the house and he appears to be conversing with a stork. A closer examination reveals that many incidents from the story of the Nativity are being told. An angel swoops down from the sky to give news of Christ's arrival to shepherds tending their flocks on the hillside. On the left side of the picture, the ships of the three Kings have arrived and the Magi are setting off with their retinues.

This charming picture is distinguished from countless depictions of the Nativity by the wonders of nature which Dürer has included. The parrot, perched on the pole by the Virgin's side, was the prophet which announced her arrival. Dürer drew this bird from an earlier study (see Fig. 29). The artist loved parrots and he later acquired several live specimens on his trip to the Netherlands in 1521. Just beneath the parrot in the watercolour is a green woodpecker, ready to hammer out a song of praise. In the bottom left corner a large stag beetle teases the Virgin's faithful but sleepy dog and a butterfly has gently alighted on its back.

All the creatures have a meaning. The chained fox is a symbol of evil. The two owls around the tree stump represent the forces of darkness, but Christ's appearance has deprived them of their power. In the bottom right corner is a crab, like the one which Dürer painted on his first visit to Venice. Among other creatures are a snail, a dragonfly, a pair of swans, a robin, a moth and a water wagtail.

Dürer has delicately added colour wash to his pen and ink drawing, blue for the sky and water, a range of greens for the landscape and traces of red for the flowers. The resulting work is extremely delicate, portraying the Virgin and Child with great tenderness and a touch of humour. Two other versions of this picture exist and the composition may well have been intended as a study for a proposed engraving.

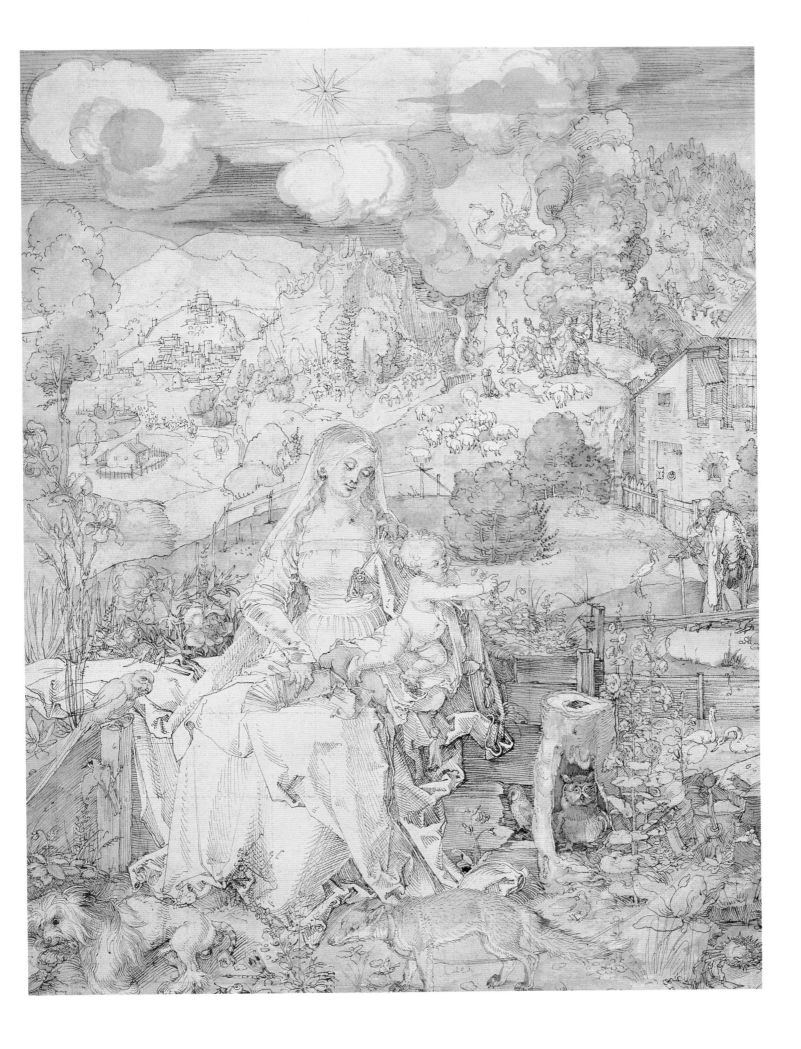

*c*1503–4. Oil on panel.
Job Castigated by his Wife, 94 x 51 cm. Städelsches Kunstinstitut, Frankfurt;
Piper and Drummer, 94 x 51 cm. Wallraf-Richartz Museum, Cologne

The central panel of the altarpiece is lost and only the wings survive, depicting the story of Job on the outside panels and four saints on the inside. The triptych was probably commissioned by Frederick the Wise for the church at his Wittenberg Palace to mark the end of the plague in 1503. Most of the painting is by Dürer, although some may have been done by his assistants.

The exteriors of the wings tell the story of Job, the upright man who refused to abandon God in the face of grave misfortune. Job's afflictions were the outcome of an argument between God and Satan over whether his faith was strong enough to survive adversity. In Dürer's panels, the body of the elderly Job is covered with boils, which made it a particularly appropriate subject for an altarpiece commissioned to mark the end of the plague. Job sits on a dunghill, in a pose of weary contemplation, and is drenched with slops which his wife pours from a wooden tub. In the upper left corner, Job's house and crops are on fire and the tiny figure of the Devil flees the destruction. The right panel depicts the figures of a piper and a drummer, who bears Dürer's own features. In the distance, behind the drummer, Job's flock of animals has been stolen and is being led away.

The insides of the wings depict four saints (see Fig. 30), set against shimmering gold backgrounds. On the left wing is St Joseph, leaning on a staff, and St Joachim. On the right wing is St Simeon and St Lazarus, with his bishop's crosier and mitre.

The altarpiece was later acquired by the Jabach family, who kept it at their family chapel in Cologne until the end of the eighteenth century. The wings were then sawn apart to separate the two sets of paintings. The exteriors, with the story of Job, were later reduced in size at the top and along the edges where they originally met. The panels are now dispersed and are unfortunately divided between three German museums. Because the central panel is lost and its subject-matter is unknown, it is more difficult to determine the significance of the wings.

Fig. 30
St Joseph and St
Joachim
*c*1503–4. Oil on panel,
96 x 54 cm. Alte
Pinakothek, Munich;

St Simeon and St
Lazarus
*c*1503–4. Oil on panel,
97 x 55 cm. Alte
Pinakothek, Munich

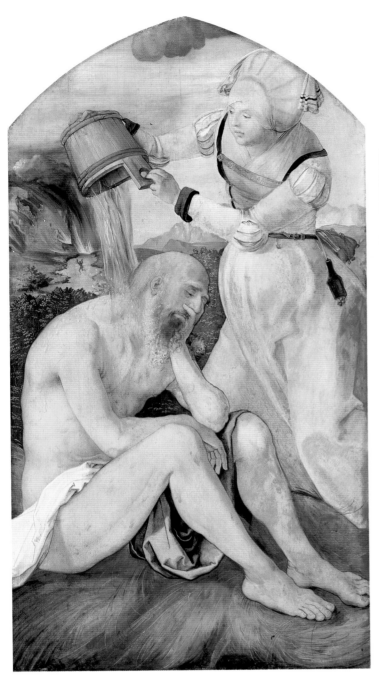
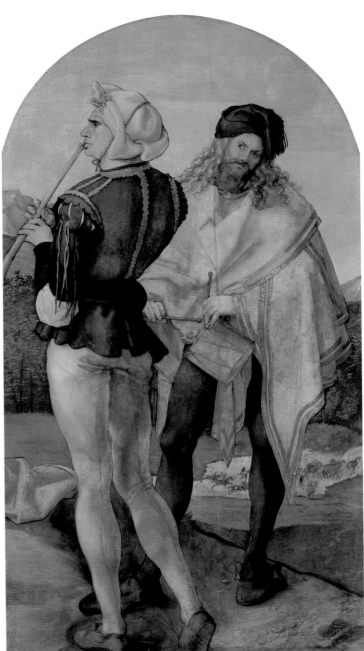

1504. Oil on panel, 100 x 114 cm. Galleria degli Uffizi, Florence

The seated Virgin is not placed in her conventional position in the centre of the picture, but to the left and depicted in profile. Christ is a playful infant, stretching forward to grasp the golden casket tenderly offered by the kneeling Caspar. The African King Balthazar and the youthful Melchior, who has Dürer's features with his long hair and beard, stand behind, offering their gifts. The architectural ruins create an impression of depth in the composition and far away rises a fortified hill town, like those which Dürer saw on his visit to Italy. The shapes and colours of the ruins, the horsemen in the background and distant landscape, all create a marvellous balance with the Nativity scene. This harmonious altarpiece was probably commissioned for Frederick the Wise's palace church at Wittenberg.

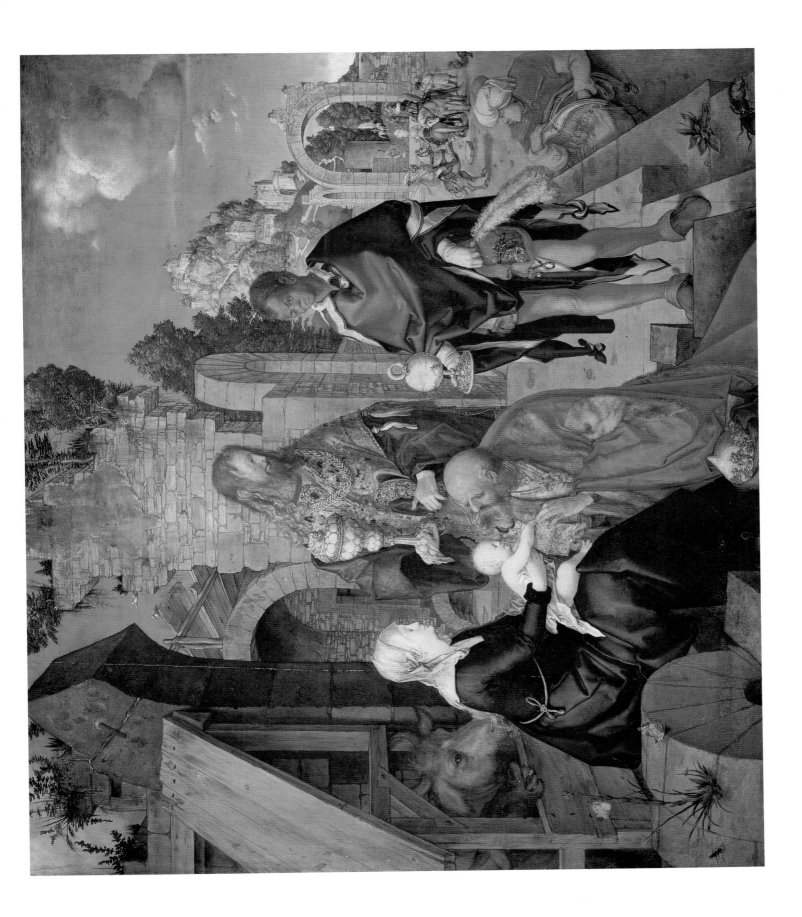

28 Portrait of a Young Venetian Woman

1505. Oil on panel, 33 x 25 cm. Kunsthistorisches Museum, Vienna

This portrait was painted soon after Dürer's arrival in Venice, on his second visit to the city in 1505. The colours create a graceful harmony, with the woman's pale flesh tones, reddish hair, necklace of black stones and pearls and patterned dress with gold trim set against a dark background. A few details of the picture remain unfinished, such as one of the bows. The portrait was discovered in a private collection in Lithuania in 1923 and the identity of the beautiful young woman remains a mystery.

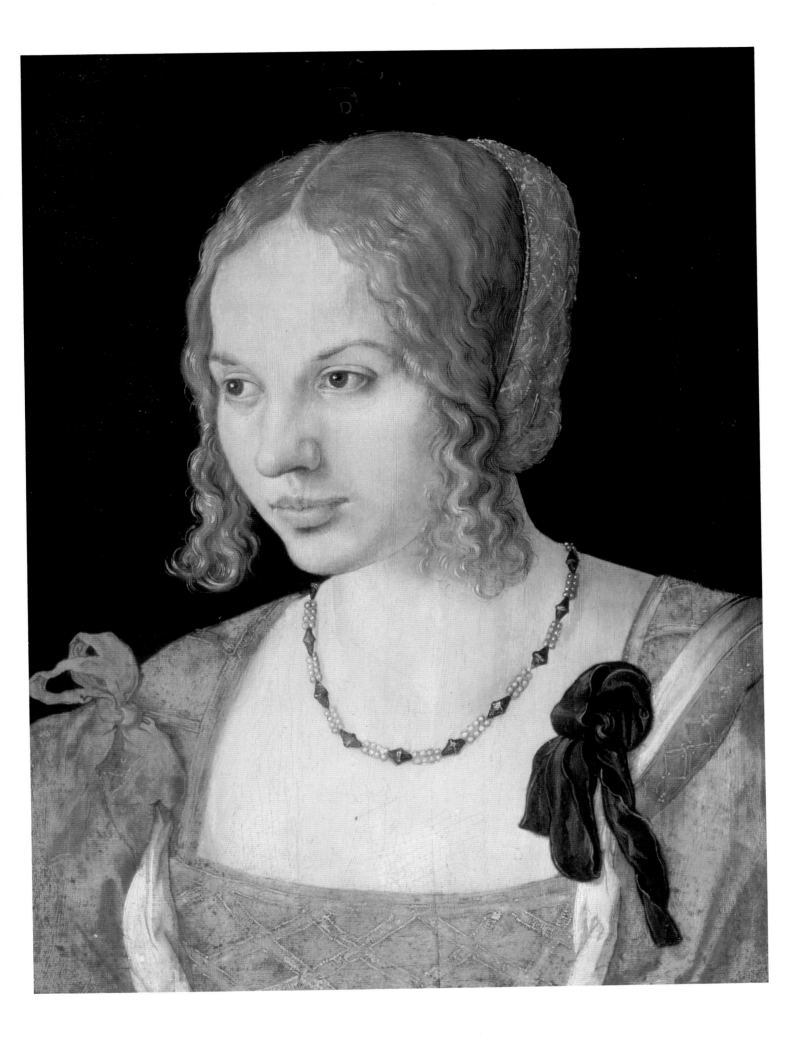

Portrait of Burkard von Speyer

1506. Oil and tempera on panel, 32 x 26 cm. Royal Collection, Windsor Castle

This striking portrait, painted in Venice, shows a thoughtful young man, richly dressed and dramatically set against a black background. His thick ginger hair, partly hidden by his dark hat, frames his face. The small part of his red shirt showing adds a dramatic touch of colour. Charles I acquired this work for the Royal Collection.

The sitter was identified as Burkard von Speyer after it was realized that he looks just like the man in a miniature in Weimar by an unknown artist, also dated 1506 and inscribed with his name. Nothing more is known about him, although presumably he originally came from Speyer, a town on the Rhine near Heidelberg. Burkard von Speyer also appears in *The Altarpiece of the Rose Garlands* (Plate 30). Wearing the same clothing, he is on the left side of the picture, just to the right of the first kneeling cardinal.

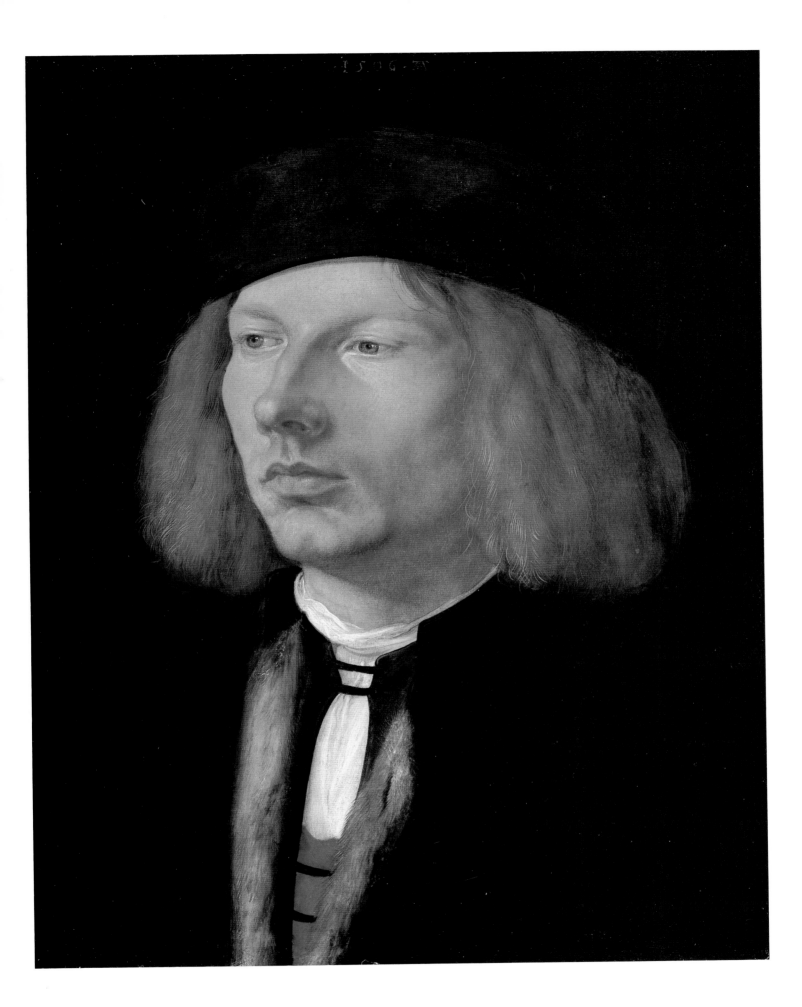

1506. Oil on panel, 162 x 194 cm. Národní Galerie, Prague

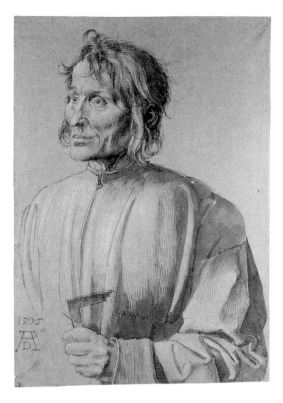

Fig. 31
Study of an Architect
1506. Brush and ink
heightened with white on
paper, 39 x 26 cm.
Kupferstichkabinett,
Berlin

This altarpiece is one of Dürer's greatest works, strongly influenced by his contact with the works of the Italian Renaissance. The angel playing the lute at the Virgin's feet has been seen as Dürer's tribute to the art of Giovanni Bellini. When in Venice, at the beginning of 1506, Dürer was commissioned to paint an altarpiece for the city's newly established Brotherhood of the Rosary, modelled on an order which had been founded in Cologne in 1475. This Brotherhood, supported by German merchants in Venice, wanted a panel for their chapel of San Bartolomeo, the church of the German community.

Dürer's painting depicts the enthroned Mary being crowned by a pair of angels. The infant Jesus holds a rose garland above his own head, like a halo. To the left of the Virgin is the figure of St Dominic dressed in black, distributing garlands to the faithful. These rose garlands symbolize the rosary. Dürer's picture has usually been called 'The Feast of the Rose Garlands' since the nineteenth century, but the festival was only introduced in 1716 and the feast itself was therefore not Dürer's theme. The artist, in his letters to Pirckheimer, simply called it 'the German picture'.

In the altarpiece, Christ is crowning the kneeling Pope, either Sixtus IV or Julius II. Opposite him on the right-hand side of the picture is the Holy Roman Emperor, either Frederick III or his son Maximilian I. The main donor, dressed in a blue gown, kneels to his right. He has not been identified with certainty, but could be the Augsburg banker Georg Fugger, who was then based in Venice.

Dürer worked very hard on the picture, and no less than 22 of his studies for the work have survived. These include a sketch of an architect holding a set square, probably Hieronymous of Augsburg (see Fig. 31). He is dressed in black at the far right of the painting, near the front. Hieronymous was then working on the reconstruction of the Fondaco dei Tedeschi, the Germans' trading house in Venice which had been destroyed by fire in 1505. Dürer has depicted himself under the tree near the right edge of the painting, beneath the landscape of the Alps. He holds a sheet of paper which is inscribed: 'Albrecht Dürer, a German, produced it within the span of five months. 1506.' His companion is likely to be Leonhard Vilt, founder of the Brotherhood of the Rosary in Venice.

When the altarpiece was completed in September 1506 it was greatly admired and among those who came to see it was the Doge, Leonardo Loredan. For a century the panel remained in the chapel of the Brotherhood of the Rosary in San Bartolomeo, but in 1606 it was removed by Emperor Rudolph II for his art collection in Prague. After being carefully wrapped, the panel was suspended from a pole and carried over the Alps by four men. During the Thirty Years' War, which started in 1618, it was taken away for safekeeping and tragically ruined by water. Much of the original paint was lost, although the extensive repainting is not immediately obvious in photographic reproductions. Among the details which have gone is a *trompe l'œil* representation of a fly which Dürer is thought to have painted on the white cloth on which the Christ child rests.

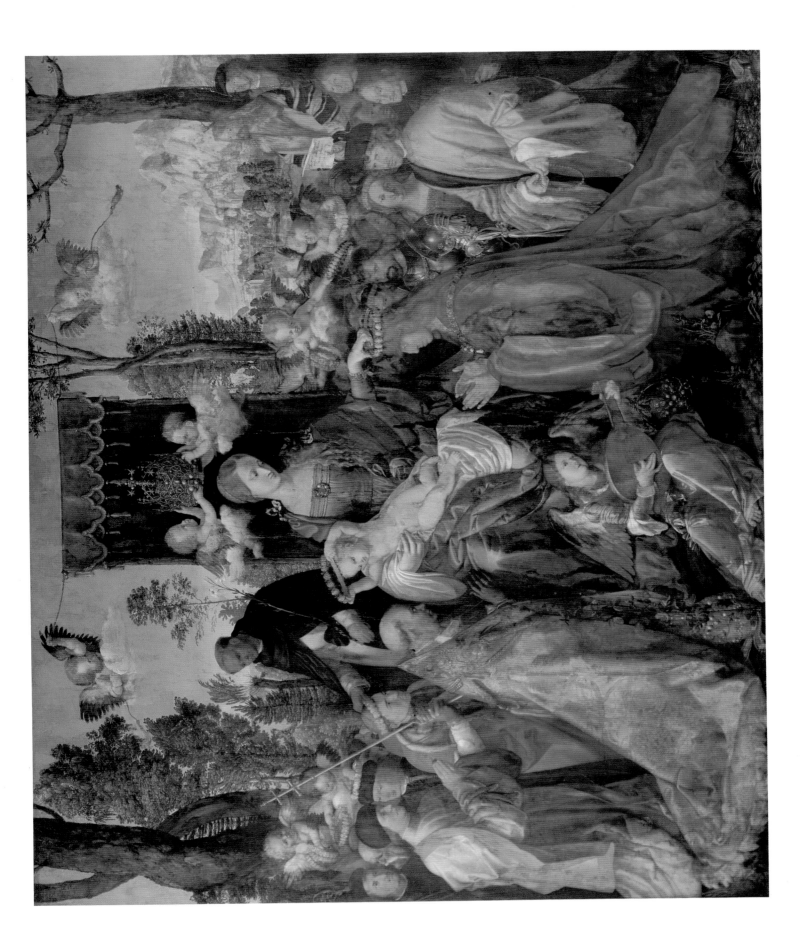

1506. Oil on panel, 65 x 80 cm. Fundación Colección Thyssen-Bornemisza, Madrid

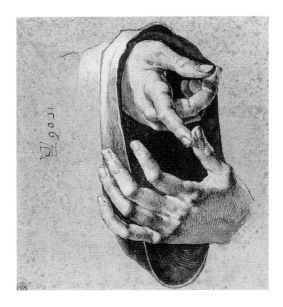

Fig. 32
Study of the Hands of
the Young Christ
1506. Pen and ink height-
ened with white on paper,
21 x 19 cm.
Germanisches
Nationalmuseum,
Nuremberg

On the bookmark at the bottom left of the panel, Dürer has recorded that this picture was 'the work of five days', a pointed reference to his inscription on *The Altarpiece of the Rose Garlands* (Plate 30), the work of five months. *Christ among the Doctors* is not only a smaller panel, but the brushwork is much more spontaneous and the paint is applied with broad and fluid strokes. Despite Dürer's statement about five days, he based it on a number of careful studies, including one of Christ's gesticulating fingers (see Fig. 32). Although not present on the original painting, two early copies of the panel have the word 'Romae' added to the inscription on the bookmark and this suggests that Dürer visited Rome late in 1506. It may also be significant that the original painting was in Rome's Galleria Barberini until its acquisition by Baron Heinrich von Thyssen-Bornemisza in 1935.

The story recorded in the panel is of Christ's visit to Solomon's Temple in Jerusalem, where he debated with the learned Jewish doctors (or scribes). According to the Bible, this was the first occasion on which Christ taught. Dürer's daring composition does not use the conventional temple setting which he earlier used in the lower left panel of *The Seven Sorrows of the Virgin* (Plate 13). Instead he gives a close-up view of the faces of six doctors crowding round the young Jesus. The elderly doctors, caricatured faces which may well have been influenced by Leonardo da Vinci, argue with Christ by quoting from the Scriptures and gesticulating. Christ, a sober boy of 12, quietly gestures with his fingers to make a point. Dürer contrasts Christ's youthful hands with the gnarled fingers of the ugly old man with the white cap and a gap-toothed grin.

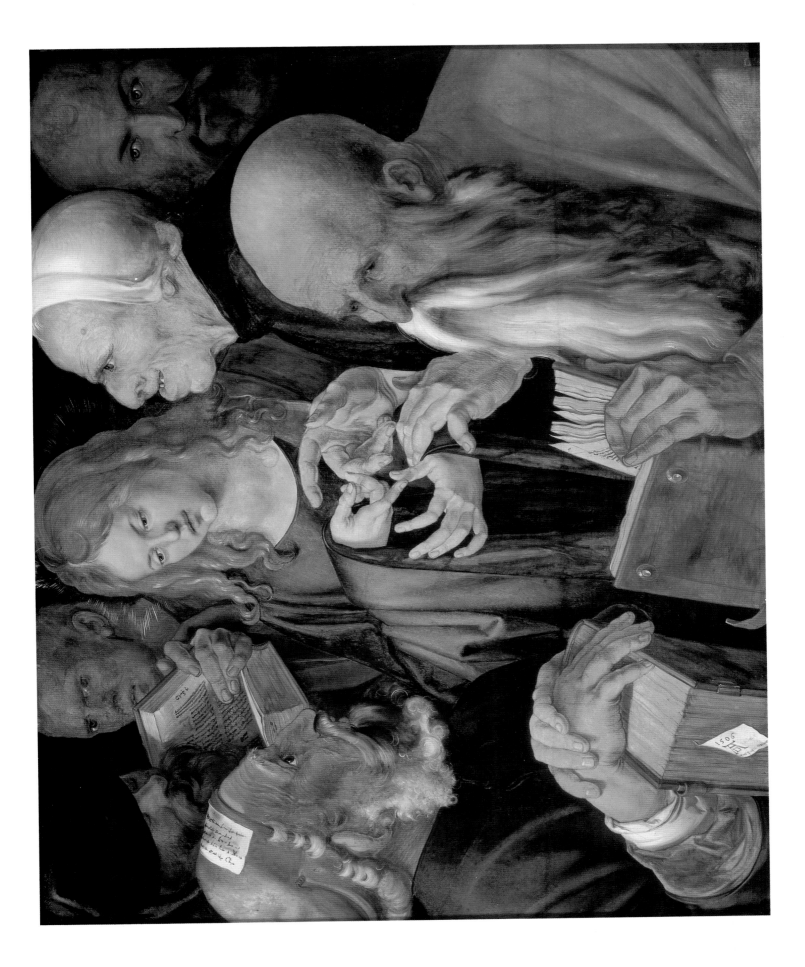

1507. Oil on panel, each 209 x 82 cm. Museo Nacional del Prado, Madrid

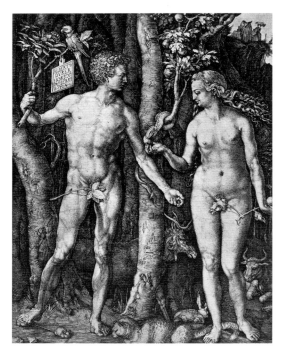

Fig. 33
Adam and Eve
1504. Engraving, 25 x 19 cm.

The subject of Adam and Eve offered Dürer the opportunity to depict the ideal human figure. Painted in Nuremberg soon after his return from Venice, the panels were influenced by Italian art. Dürer's colouring is muted, and he models the bodies with the help of light and shadow, making the figures emerge from the dark background. Adam and Eve are noticably slimmer than in his engraving of three years earlier (see Fig. 33).

Dürer's *Adam and Eve* represent the earliest known life-size nudes in Northern art. Eve, whose skin is whiter than Adam's, is next to the Tree of Knowledge, standing in a curious position with one foot behind the other. Her right hand rests on a bough and with her left hand she accepts the ripe apple offered by the coiled serpent. On a tablet is the inscription: 'Albrecht Dürer, Upper German, made this 1507 years after the Virgin's offspring.' Adam inclines his head towards Eve and stretches out the fingers of his right hand on the other side, creating a sense of balance.

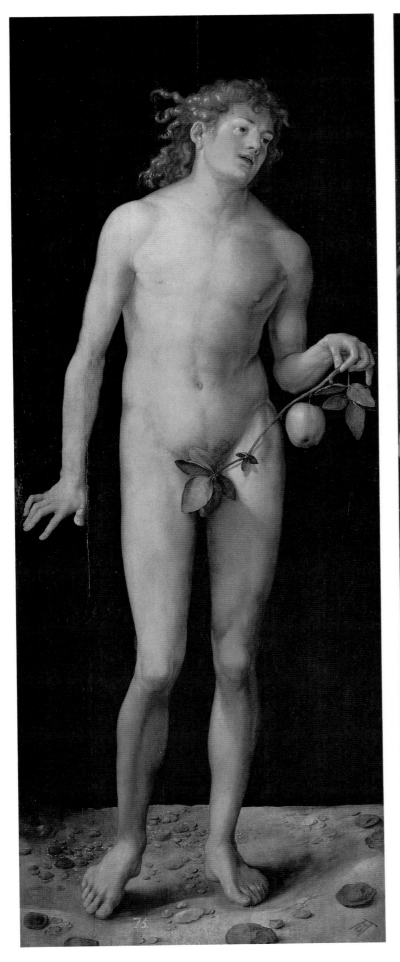
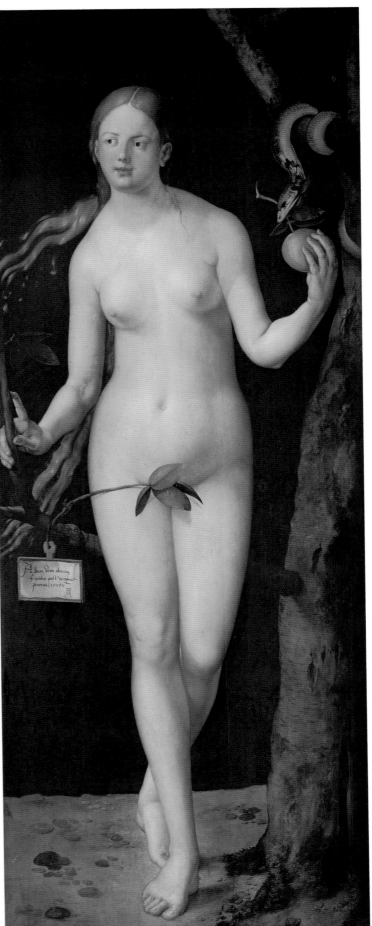

The Martyrdom of the Ten Thousand

1508. Oil on canvas, transferred from panel, 99 x 87 cm. Kunsthistorisches Museum, Vienna

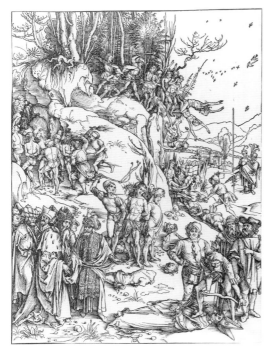

Fig. 34
The Martyrdom of
the Ten Thousand
1497–8. Woodcut, 39 x 28 cm.

The altarpiece depicts the legend of the ten thousand Christians who were martyred on Mount Ararat, in a massacre perpetrated by the Persian King Saporat on the command of the Roman Emperors Hadrian and Antonius. Dürer had depicted this massacre a decade earlier in a woodcut (see Fig. 34). The painting was commissioned by Frederick the Wise, who owned relics from the massacre, and it was placed in the relic chamber of his palace church in Wittenberg. Although Dürer had never before tackled a painting with so many figures, he succeeded in integrating them into a flowing composition using vibrant colour.

Dürer's gruesome scene depicts scores of Christians meeting a violent death in a rocky landscape, providing a veritable compendium of tortures and killings. The oriental potentate in the blue cloak and turban who is directing the action in the lower right corner of the picture would in Dürer's time have been perceived as a reference to the threat of Turkish invasion, because of the seizure of Constantinople in 1453. In the centre of the painting is the rather incongruous figure of the artist, holding a staff with the inscription: 'This work was done in the year 1508 by Albrecht Dürer, German.' The man walking with him through this scene of carnage is probably the scholar Konrad Celtis, a friend of Dürer's who had died just before the painting was completed.

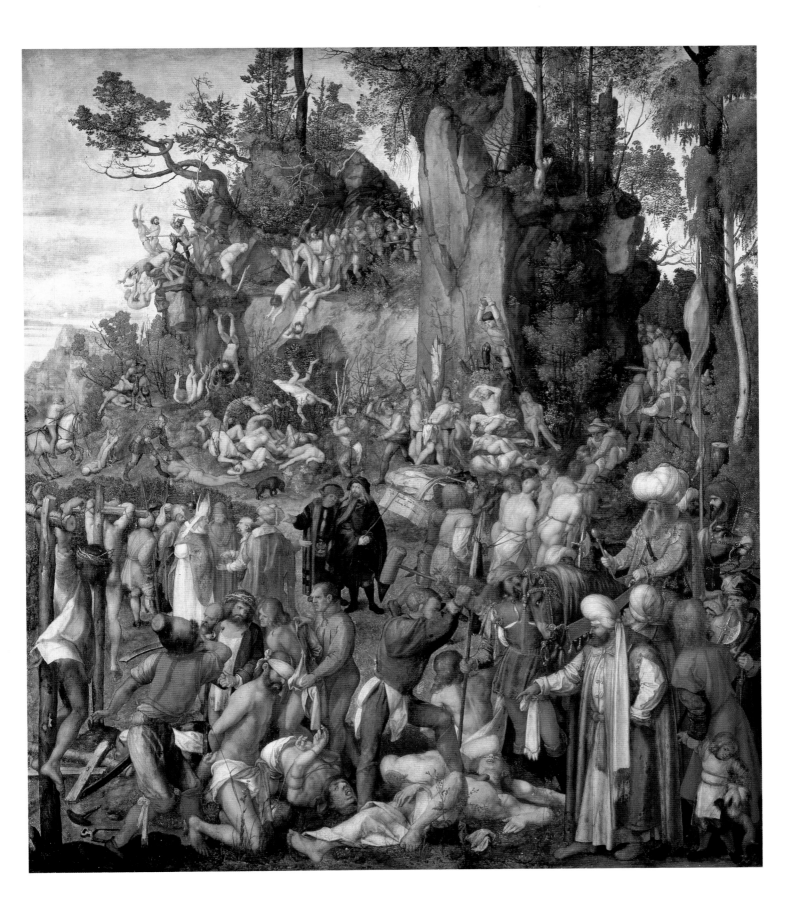

The Adoration of the Holy Trinity

1511. Oil on panel, 135 x 126 cm. Kunsthistorisches Museum, Vienna

Fig. 35
Design for the
Landauer Altarpiece
1508. Pen and ink and
watercolour on paper,
39 x 26 cm.
Musée Condé, Chantilly

This work was commissioned by the Nuremberg metal trader Matthäus Landauer. Also known as the Landauer Altarpiece, it was ordered for the chapel of the Twelve-Brothers House, which he endowed for a dozen impoverished artistans.

In the centre of the painted panel at the top is the Trinity. God the Father is shown as emperor, holding Christ on the Cross and surmounted by the dove of the Holy Ghost. Around the figure of God are two rings of angels. Below them, to the right, are Old Testament figures and, to the left, followers of Christ bearing palm branches. Nearer the base of the picture are the slightly larger figures of the living, led by the Pope (with a blue tiara) and the Emperor (with a golden crown). The grey-haired figure of Matthäus Landauer, the donor, is depicted on the left, being welcomed into the throng by the outstretched hand of a cardinal.

The landscape at the bottom of the panel stretches into the far distance. A lone figure stands on the land – the artist, who has depicted the earthly community being reunited with the realm of heaven. His hand rests on a panel which is inscribed: 'Albrecht Dürer of Nuremberg made this 1511 years after the Virgin.'

Dürer also designed an ornate frame for the altarpiece. An early drawing for the frame and panel is dated 1508 and shows that they were a carefully designed ensemble (see Fig. 35). The frame still survives in the Germanisches Nationalmuseum, Nuremberg, although unfortunately it has long been separated from the painting. (The frame shown opposite is an exact replica of the original.) Made of carved and painted wood, the top of the frame has a sculpted depiction of the Last Judgement, with God enthroned and surrounded by the kneeling figures of the Virgin and John the Baptist. An inscription on the base of the frame records: 'Matthäus Landauer has finally completed the house of worship of the Twelve Bretheren including the donation of this panel. After Christ's birth, the year 1511.' Dürer's workshop also designed stained-glass windows for the Twelve-Brothers Chapel, but these were removed in 1810 and were destroyed in Berlin during the Second World War.

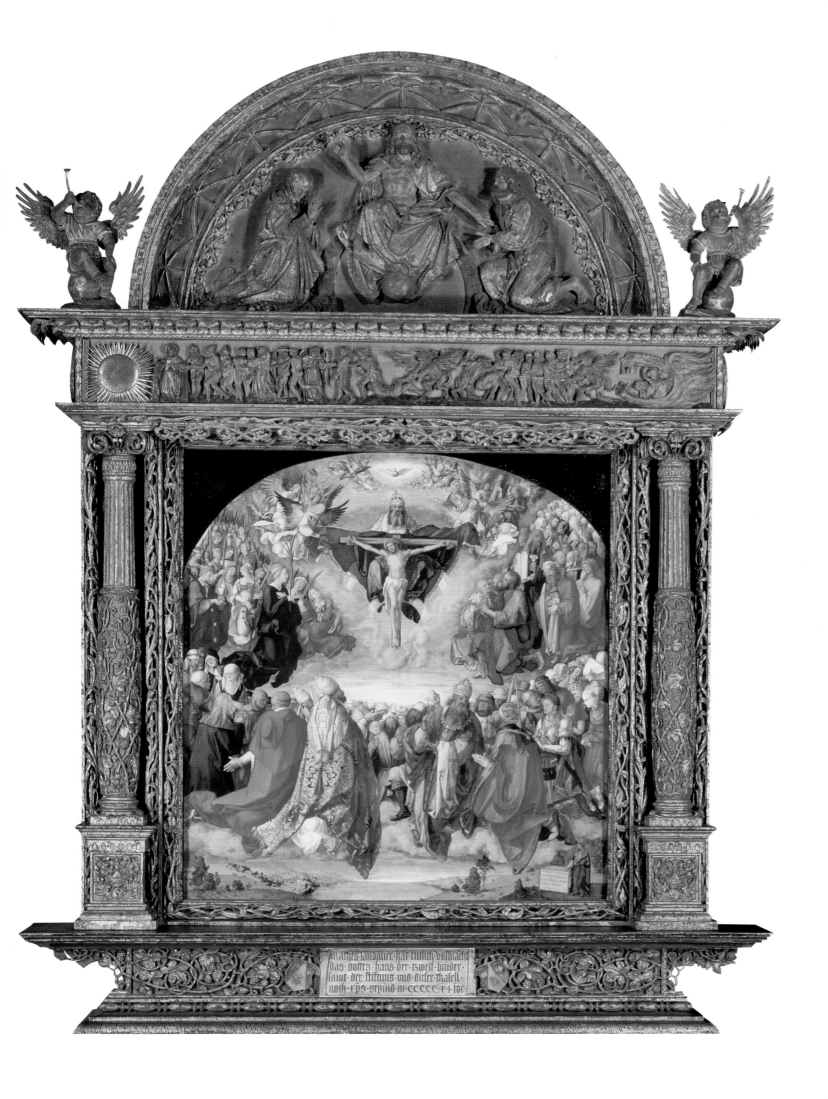

Wing of a Roller

1512. Watercolour and gouache on vellum, 20 x 20 cm. Graphische Sammlung Albertina, Vienna

The rendering of the spectacular, shimmering colours is astonishing. The bird is the roller, which is found in southern and central Europe, and Dürer has represented the upper side of the left wing, probably actual size. The fine detail of the painting makes it possible to see how the shorter feathers overlap the longer ones, how, as they approach the bone, the green feathers become more numerous and downy, and how the brown feathers near the breast hang down in tufts.

Although the 1512 date on the watercolour is probably correct, it is possible that it may have been done earlier. Dürer depicted bird wings in his engravings of *Nemesis* in around 1502 and *Coat of Arms of Death* in 1503. He was always intrigued by exotic birds and in 1506 he brought back feathers from Venice for Pirckheimer.

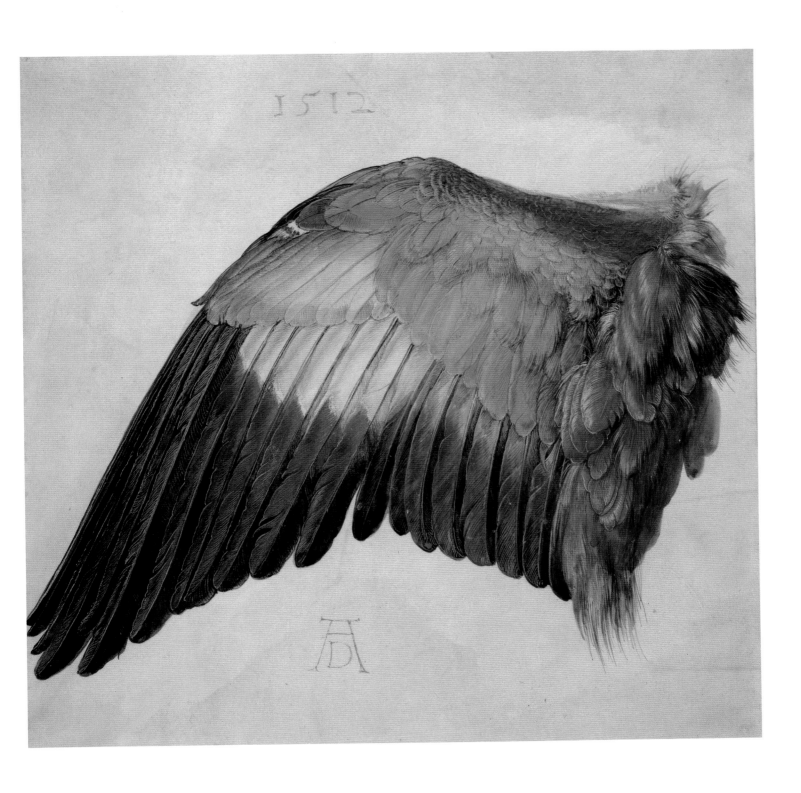

Virgin and Child with Half a Pear

1512. Oil on panel, 49 x 37 cm. Kunsthistorisches Museum, Vienna

The Virgin and Child was Dürer's favourite subject for paintings and no doubt highly popular with patrons. Mary, dressed in a rich blue robe and set against a dark background, gazes down adoringly at her baby. Her veil almost touches the child's head, following its contours. The Virgin's thumb and finger at the bottom of the picture emphasize the fragility of the child's body. Jesus holds the top half of a neatly sliced pear which his mother has cut for him. He has already taken a small bite with the two tiny upper teeth which have just begun to grow. This is a harmonious picture, in terms of colour, composition and subject-matter.

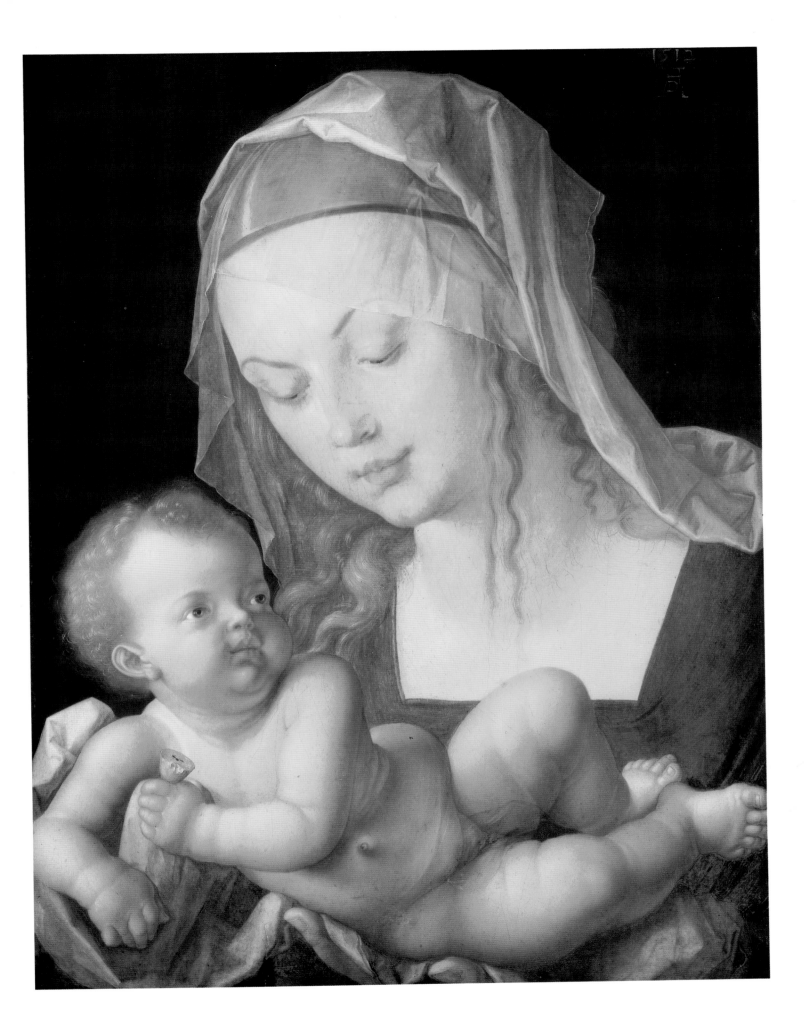

Emperor Charlemagne and Emperor Sigismund

1513. Oil and tempera on panel, each 215 x 115 cm (including frame). Germanisches Nationalmuseum, Nuremberg

Fig. 36
Study of Emperor
Charlemagne and
Emperor Sigismund
c1510. Pen and ink and
watercolour on paper,
18 x 21 cm.
Courtauld Institute
Galleries, London

Dürer's only commission for panel paintings from Nuremberg's city council was for a pair of portraits of the Emperors Charlemagne and Sigismund. These were ordered for the Treasure Chamber in the Schopper House, where the imperial regalia were kept the night before they went on ceremonial display on the Friday after Easter. For the rest of the year the regalia were housed in the Church of the Hospital of the Holy Ghost. Dürer was probably commissioned for the portraits in 1510 and received his final payment three years later. His panels are believed to have been ordered to replace two earlier works, now lost, which had been painted soon after the regalia were brought to Nuremberg in 1424.

The half-length pictures are larger than life. No likenesses are known of Charlemagne, who ruled from 800–14, and Dürer therefore invented his portrait, presenting him frontally in an imposing posture. His interpretation of Charlemagne's appearance was to influence depictions of the Emperor until well into the nineteenth century. For Sigismund, who ruled from 1410–37, Dürer must have had access to a portrait done during his reign.

The two paintings include the appropriate coats of arms, the German eagle and French fleur-de-lis for Charlemagne and the arms of the five territories ruled by Sigismund, the German Empire, Bohemia, Old and New Hungary and Luxembourg. Inscriptions name the two men and state the number of years they ruled, 14 years for Charlemagne and 28 for Sigismund. Around the four sides of the panels are explanatory texts on the frames. The first records: 'Charlemagne reigned for 14 years. He was the son of the Frankish King Pippin, and Roman Emperor. He made the Roman Empire subject to German rule. His crown and garments are put on public display annually in Nuremberg, together with other relics.' On the second panel is the text: 'Emperor Sigismund ruled for 28 years. He was always well-disposed to the city of Nuremberg, bestowing upon it many special signs of his favour. In the year 1424, he brought here from Prague the relics that are shown every year.'

Although the two panels were originally designed as a diptych (see Fig. 36), they were ultimately displayed separately. Other texts on the reverse of the panels suggest that the painted side was normally hung facing the wall, with the portraits only being shown on special occasions, presumably for the annual display of the regalia. The two panels were hung on either side of the shrine in which the relics were housed.

Dürer prepared studies of the individual pieces of the regalia and reproduced them with great accuracy. Charlemagne wears the imperial crown and brandishes his sword and orb. Sigismund has a Gothic crown and holds a sceptre and orb. The annual display of the imperial regalia ended in 1525 and Dürer's panels were then moved to the city hall. Since 1880 they have been on loan to the Germanisches Museum in Nuremberg. As for the regalia, the Habsburgs later took them to Vienna where they remained in the imperial treasury, except for a brief period when they were seized by the Nazis and returned to Nuremberg.

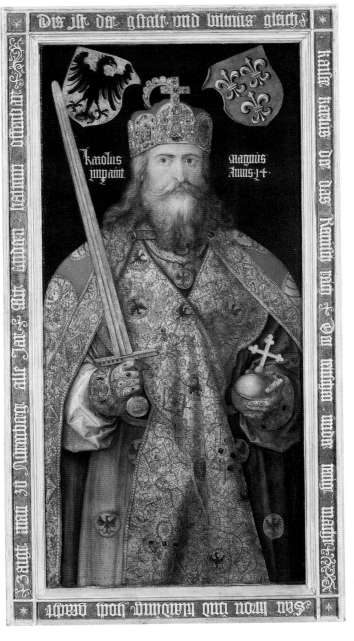

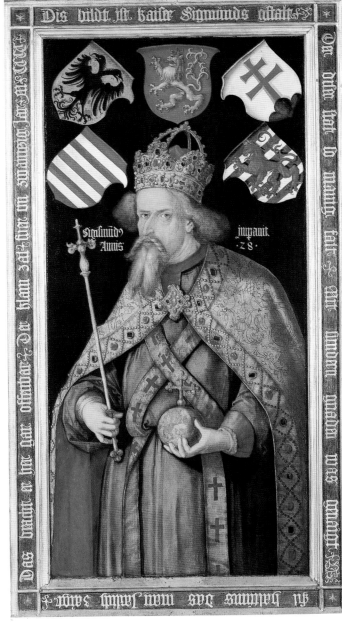

Cupid the Honey Thief

1514. Pen and ink and watercolour on paper, 22 x 31 cm. Kunsthistorisches Museum, Vienna

This delightful watercolour tells the story of Cupid, the god of love, who ran to his mother Venus, vainly trying to escape a swarm of bees whose honeycomb he had stolen. In his rush to escape, Cupid dropped his arrows. According to the fable told by the Greek poet Theocritus, in his *Idylls*, Venus laughs and says: 'Are you not just like the bee – so little yet able to inflict such painful wounds?' *Cupid the Honey Thief* was part of a series of watercolour illustrations of mythological subjects which Dürer painted in 1514.

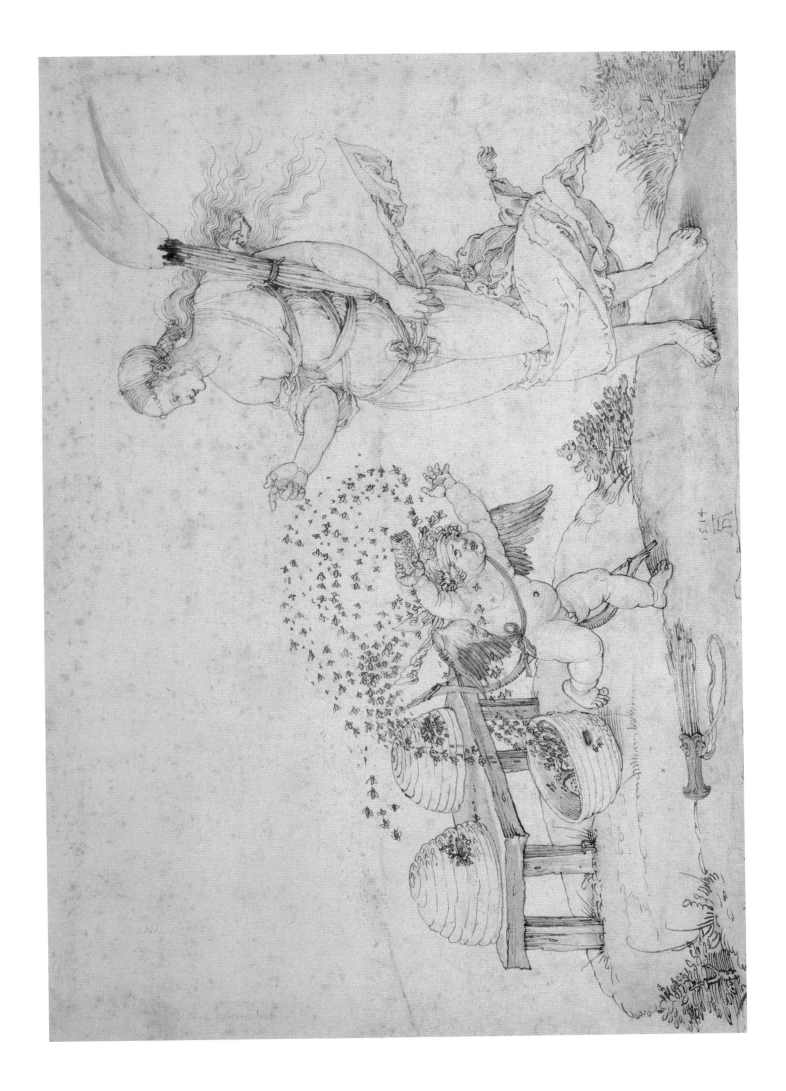

Portrait of Michael Wolgemut

1516. Oil and tempera on panel, 29 x 27 cm. Germanisches Nationalmuseum, Nuremberg

After he had achieved great fame, Dürer depicted the master who had taught him to paint. On it he inscribed: 'This portrait was done by Albrecht Dürer of his teacher, Michael Wolgemut, in 1516', to which he later added, 'and he was 82 years old, and he lived until 1519, when he departed this life on St Andrew's Day morning before sunrise.' It is unclear from the inscription whether Wolgemut was 82 when he died or when the portrait had been painted three years earlier.

Michael Wolgemut (1434/7–1519) had one of the largest artist's workshops in Germany. Dürer had served his apprenticeship there from 1486 until 1489 and Wolgemut must have been proud to have witnessed his former pupil's rapid success. In Dürer's portrait, everything is focused on the head, set against a neutral green background. The old man's features are not disguised, from his sunken eyes and gaunt cheeks to the loose skin around his neck. Wolgemut wears a fur-lined coat and a simple hat or scarf, perhaps the headgear he would have worn in his workshop to keep off the dust. His eyes are still alert and he has a thoughtful expression. Dürer does not depict a pitiable man, but marvels at his indomitable spirit.

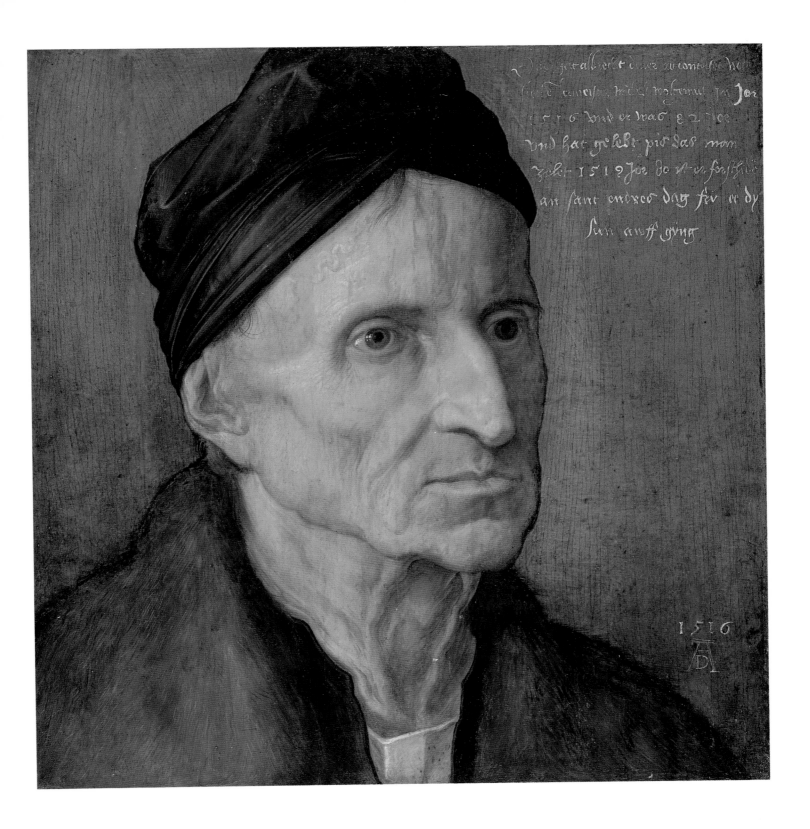

Die jar albrecht dürer auconters hat
beüst demeister mit d[er] zalbenut Jm Jar
1516 vnd er was 82 Jor
vnd hat gelebt pis das man
zelet 1519 Jor do ist er ferstorben
an sant endres dag fri ee dy
sun auff ging

1516

Apostle Philip

1516. Tempera on canvas, 46 x 38 cm. Galleria degli Uffizi, Florence

These idealized portraits depict the two apostles, Philip and James the Elder (see Fig. 37). The compositions are very simple, with Dürer showing just the head and shoulders. Only the inscriptions, and the scallop shell symbol on the red gown of James, identify them as apostles. Dürer has portrayed them in an anguished state, with heads slightly bent, furrowed brows, piercing eyes and dropped lower lips. Grief has aged them and their intricately painted beards give them the appearance of wise old men. Dürer probably intended the two portraits to be part of a set of paintings of the 12 apostles.

Fig. 37
Apostle James
1516. Tempera on
canvas, 46 x 38 cm.
Galleria degli Uffizi,
Florence

SANCTE
PRONOBIS

PHILIPPE ORATE
1516. AD

Portrait of Maximilian I

1519. Oil on panel, 74 x 62 cm. Kunsthistorisches Museum, Vienna

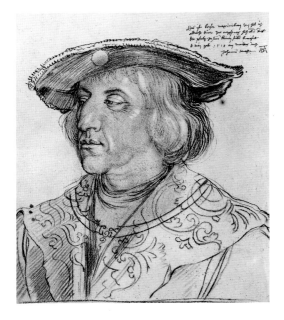

Fig. 38
Portrait of Maximilian I
1518. Charcoal and
coloured chalk on paper,
38 x 32 cm. Graphische
Sammlung Albertina,
Vienna

Maximilian I of Austria (1459–1519) became head of the Habsburgs in 1493 and was elected Holy Roman Emperor in 1508. He was a learned ruler with a strong interest in the arts. Dürer first met him during a visit to Nuremberg in 1512 and was commissioned to work on the gigantic woodcuts of *The Triumphal Arch* and *The Triumphal Procession*, as well as decorations for Maximilian's prayer book. In 1515 he was awarded an annual payment of 100 florins by the Emperor.

On 28 June 1518 Dürer had sketched Maximilian during the Imperial Diet at Augsburg (see Fig. 38). He inscribed the drawing: 'This is Emperor Maximilian, whom I, Albrecht Dürer, portrayed up in his small chamber in the tower at Augsburg on the Monday after the feast day of John the Baptist in the year 1518.' In the relatively informal sketch Dürer captured a hint of the fatigued resignation of the 59 year-old ruler.

Maxmilian I died on 12 January 1519 and Dürer then used his drawing as the basis for a woodcut and two painted portraits, one in tempera (Germanisches Nationalmuseum, Nuremberg) and this one in oil. These finished works are formal portraits and lack some of the human character which comes out in the original sketch. In the oil portrait, the Emperor is dressed in an elegant fur, which Dürer has painted with great care. Instead of an orb, the Emperor holds a broken pomegranate, a symbol of the Resurrection and Maximilian's personal emblem. At the top of the picture is the Habsburg coat of arms with the double-headed eagle and a lengthy inscription on Maximilian's achievements. The Emperor looks aloof and withdrawn, an expression of his dignity.

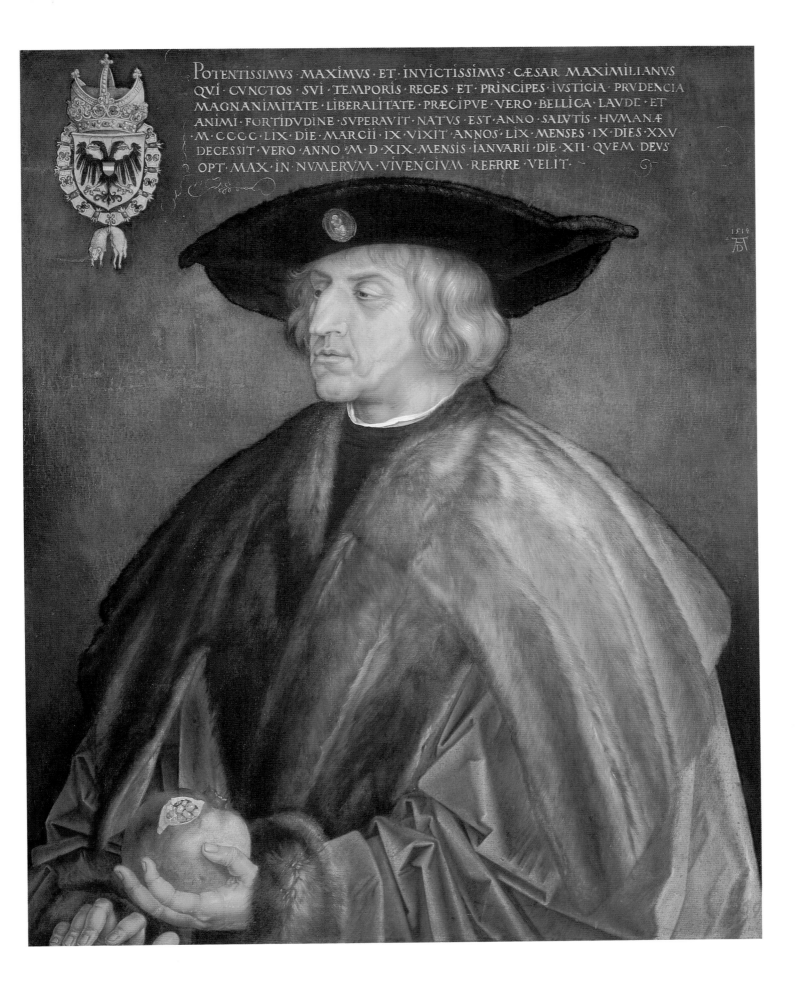

POTENTISSIMVS MAXIMVS ET INVICTISSIMVS CAESAR MAXIMILIANVS
QVI CVNCTOS SVI TEMPORIS REGES ET PRINCIPES IVSTICIA PRVDENCIA
MAGNANIMITATE LIBERALITATE PRAECIPVE VERO BELLICA LAVDE ET
ANIMI FORTIDVDINE SVPERAVIT NATVS EST ANNO SALVTIS HVMANAE
M.CCCC.LIX DIE MARCII IX VIXIT ANNOS LIX MENSES IX DIES XXV
DECESSIT VERO ANNO M.D.XIX MENSIS IANVARII DIE XII QVEM DEVS
OPT. MAX. IN NVMERVM VIVENCIVM REFERRE VELIT

St Anne with the Virgin and Child

1519. Oil and tempera on canvas, transferred from panel, 60 x 50 cm. Metropolitan Museum of Art, New York

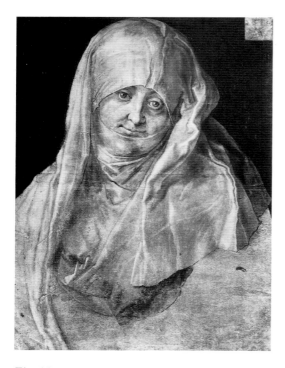

Fig. 39
Study of St Anne
1519. Brush and ink
heightened with white on
paper, 40 x 29 cm.
Graphische Sammlung
Albertina, Vienna

Dürer's work is triangular in composition. St Anne, the mother of the Virgin, places her left hand on her daughter's shoulder, in a gesture of consolation. The youthful Mary worships the child, her hands together in silent prayer. The infant rests against St Anne. His expression suggests not only sleep, but death, as the two women seem to understand. A study survives of the half-length figure of St Anne (see Fig. 39), probably based on Dürer's wife Agnes, then in her mid-forties. In the painting, St Anne's features have been softened and she appears younger. The picture was commissioned by Leonard Tucher, a member of the Nuremberg family whose portraits Dürer had painted earlier (see Plate 18).

St Jerome

1521. Oil on panel, 60 x 48 cm. Museu Nacional de Arte Antiga, Lisbon

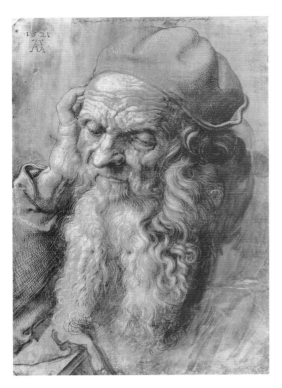

Fig. 40
Study of a Man Aged 93
1521. Brush and pen and ink
heightened with white on
paper, 42 x 28 cm.
Graphische Sammlung
Albertina, Vienna

Dürer painted *St Jerome* in Antwerp in March 1521 and presented the panel to his friend Rodrigo Fernandez d'Almada. He wrote in his diary: 'I painted a Jerome carefully in oils and gave it to Rodrigo of Portugal.' The panel was displayed in the merchant's private chapel in Antwerp and was later taken back to Portugal.

The figure of the saint is based on a drawing of an old bearded man (see Fig. 40). On the drawing, Dürer inscribed: 'The man was 93 years old and yet healthy and strong in Antwerp.' The skull in the painting, which Dürer had also sketched separately (Graphische Sammlung Albertina, Vienna), was probably the 'little skull' which he had recorded buying for two pennies several months earlier in Cologne.

In the painting, St Jerome, bearing the wrinkled features of the 93 year-old, rests his right hand against his head, in a contemplative pose. With his index finger of the other hand he lightly touches the skull, a symbol of the brevity of life. The skull is symbolically placed between the open Bible on a small lectern and the ink-well, a reminder of the saint's role as the translator of the Bible. The aged St Jerome looks despondently out of the picture. Dürer's painting was strongly influenced by Flemish art, particularly the work of Quentin Massys.

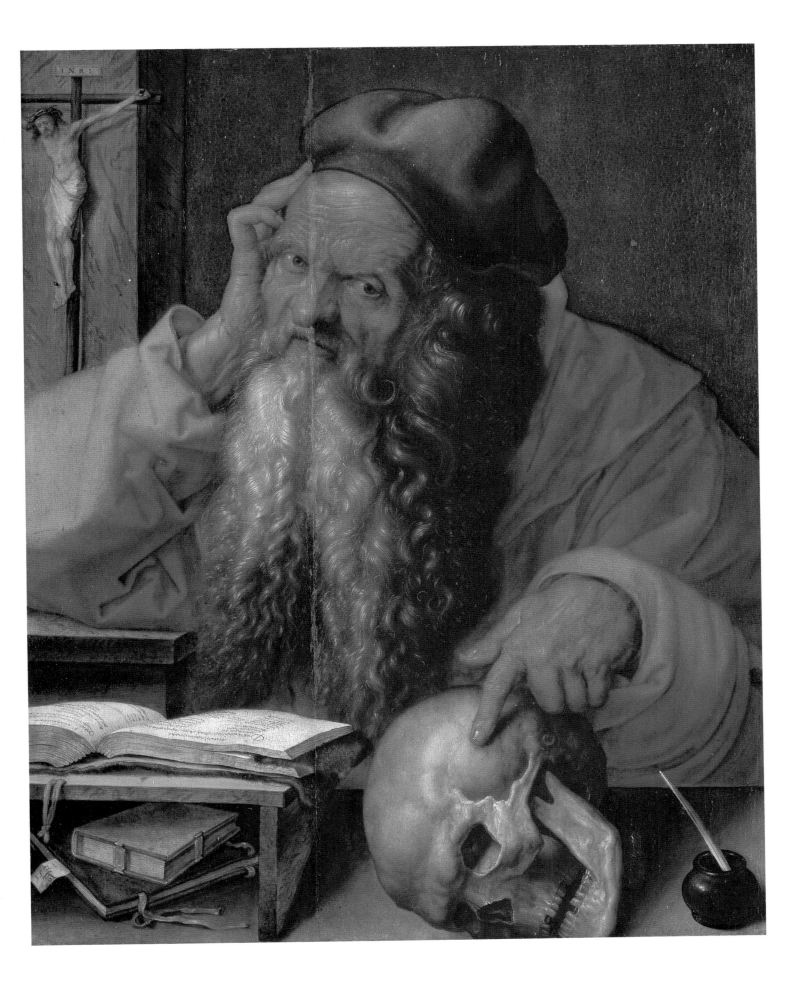

44 Portrait of Bernhard von Reesen

1521. Oil on panel, 46 x 32 cm. Gemäldegalerie Alte Meister, Dresden

The man in the portrait holds a message on which the first few letters of his name can be read 'P[or B]ernh', the rest being hidden by the fingers of his left hand. This is almost certainly the painting to which Dürer refers in his Antwerp diary in late March 1521, recording that he had 'made a portrait of Bernhart von Resten in oils' for which he had been paid eight florins. Dürer's reference is probably to Bernhard von Reesen (1491–1521), a Danzig merchant whose family had important business links with Antwerp. His name suggests that that his family originated from Rees, a town on the Lower Rhine 100 miles east of Antwerp.

Dürer's tight composition cuts off the two edges of Reesen's hat, emphasizing his brightly lit face. The dark clothing and hat also draw attention to his features – his pronounced cheekbones, forceful chin and youthful expression. His eyes stare out into the distance. Reesen, who was 30 when he was painted, died from the plague just a few months later in October 1521.

1525. Watercolour on paper, 30 x 43 cm. Kunsthistorisches Museum, Vienna

The watercolour and accompanying text describe an apocalyptic dream which Dürer had on the night of 7–8 June 1525. The picture depicts a landscape with scattered trees. An enormous column of water gushes down, spreading out near the ground and flooding, while other smaller columns of water start to fall from the heavens. The dream occurred during a period of great religious uncertainty, with the birth of the Reformation, and many people feared that a flood would destroy the world.

Below the watercolour Dürer wrote a description of his dream:

'In 1525, during the night between Wednesday and Thursday after Whitsuntide, I had this vision in my sleep, and saw how many great waters fell from heaven. The first struck the ground about four miles away from me with such a terrible force, enormous noise and splashing that it drowned the entire countryside. I was so greatly shocked at this that I awoke before the cloudburst. And the ensuing downpour was huge. Some of the waters fell some distance away and some close by. And they came from such a height that they seemed to fall at an equally slow pace. But the very first water that hit the ground so suddenly had fallen at such velocity, and was accompanied by wind and roaring so frightening, that when I awoke my whole body trembled and I could not recover for a long time. When I arose in the morning, I painted the above as I had seen it. May the Lord turn all things to the best.'

In the draft of his unpublished 'Nourishment for Young Painters', dating from over a decade earlier, Dürer had written: 'How often do I see great art in my sleep, but on waking cannot recall it; as soon as I awake, my memory forgets it.' But on this occasion, Dürer made great efforts to recall the dream and painstakingly recorded it in an image and words. The result is probably one of the most realistic early depictions of a scene accurately recalled from a dream, as opposed to more composed visions which had previously figured in European paintings and illuminated manuscripts.

1526. Oil on panel, 51 x 37 cm. Staatliche Museen zu Berlin – Preussischer Kulturbesitz Gemäldegalerie, Berlin

Hieronymous Holzschuher (1469–1529) was a close friend of Dürer. He was a learned man, from a powerful local family, and had served as mayor of Nuremberg in 1509. The portrait is still in its original frame, which has a sliding cover with the Holzschuher arms and those of his wife's family, Müntzer. The painting remained with the Holzschuhers until its sale in 1882.

Dürer inscribed Holzschuher's name at the top of the portrait along with his age, 57, and the year 1526. Holzschuher has a powerful physical presence. His penetrating eyes look straight out of the picture, making him appear very alert. The strong nose is finely painted, helping to give his face a three-dimensional appearance. Holzschuher's beard hides his neck and his dishevelled, silvery hair frames his face.

Dürer was renowned for his ability to paint details, such as hair, realistically and it was pictures like this which are said to have led to his famous conversation with Giovanni Bellini in 1505 or 1506. The elderly Venetian painter had asked Dürer for one of the brushes which he used to execute his painstaking portraits. Dürer then handed Bellini a brush identical to ones the Venetian artist already used. 'I do not mean this, I mean the brushes you use to paint several hairs with one touch,' Bellini responded. Dürer picked up the brush and demonstrated how he painted.

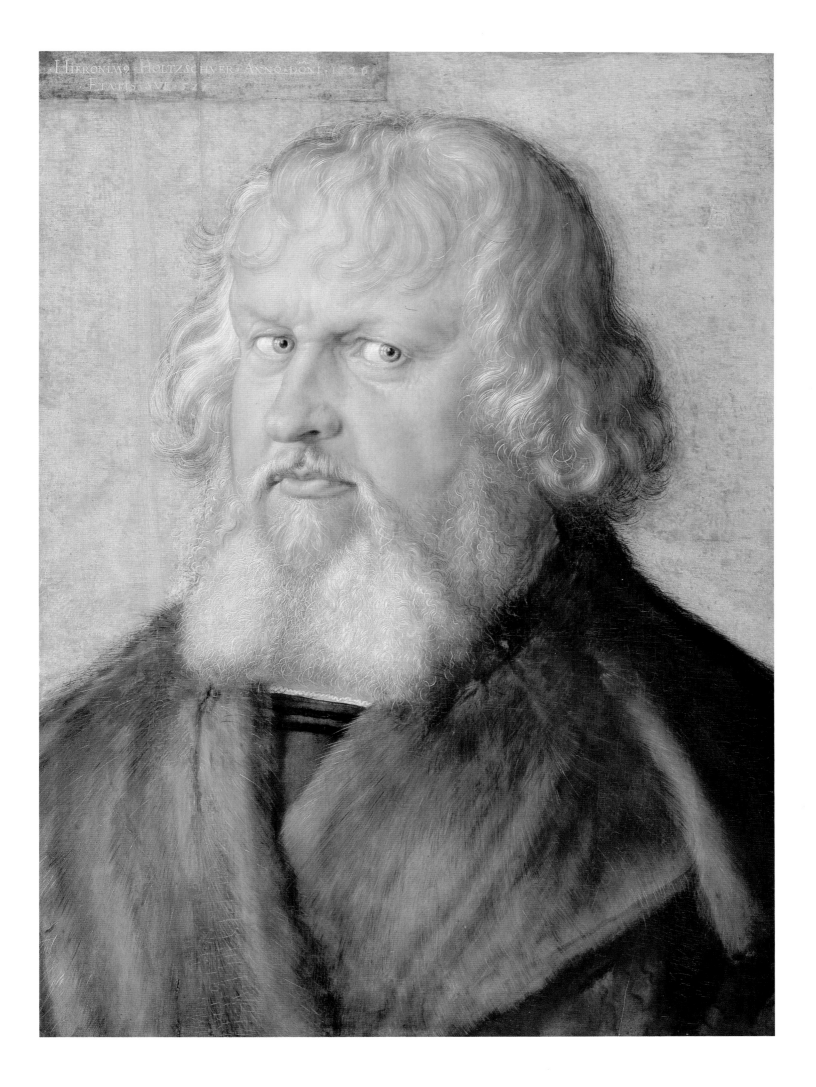

Portrait of Johannes Kleberger

1526. Oil on panel, 37 x 37 cm. Kunsthistorisches Museum, Vienna

Johannes Kleberger (1486–1546) was a Nuremberg merchant who had worked in France and Switzerland and returned to the city in 1526. Dürer painted Kleberger that year, making him resemble a classical bust or medallion. This illusionistic treatment, giving the portrait a sculptural appearance, was an innovation. Around Kleberger's head is an inscription with his name and age, 40. In the top left corner is a form of the astrological sign of Leo, in the bottom left is Kleberger's coat of arms, and in the bottom right the insignia around his helmet.

Kleberger, whom Dürer has portrayed as a determined man, was a highly controversial figure. In 1528 he married Pirckheimer's daughter Felicitas, against her father's will. Just a few days later, for unknown reasons, Kleberger suddenly left Nuremberg without her and emigrated to Lyons. There he eventually gave away much of his great wealth to the poor.

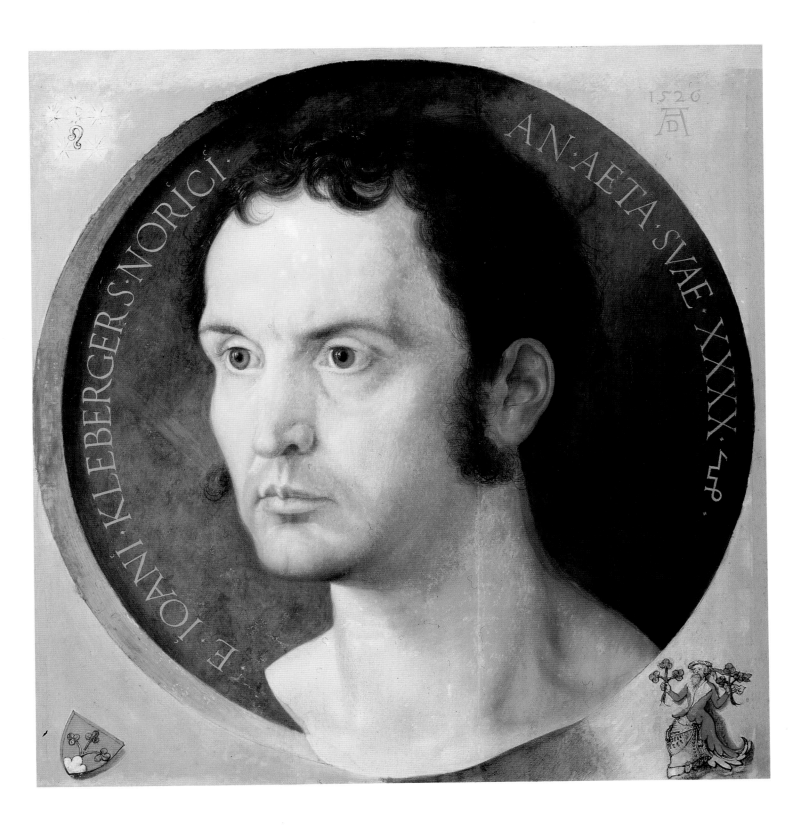

The Four Holy Men

1526. Oil on panel, each 215 x 76 cm. Alte Pinakothek, Munich

On 6 October 1526 the artist offered *The Four Holy Men* to the city fathers of Nuremberg: 'I have been intending, for a long time past, to show my respect for your excellencies by the presentation of some humble picture of mine as a remembrance; but I have been prevented from so doing by the imperfection and insignificance of my works... Now, however, that I have just painted a panel upon which I have bestowed more trouble than on any other painting, I considered none more worthy to keep it as a memorial than your excellencies.' The council gratefully accepted the gift, hanging the two works in the upper government chamber of the city hall. Dürer was awarded an honorarium of 100 florins.

Despite the presence of the Evangelist Mark, the pair of panels with their slightly larger than life-size figures have since the 1530s usually been called 'The Four Apostles', although *The Four Holy Men* is a more accurate title. John the Evanglist stands on the far left, holding an open New Testament from which he is reading the first verses of his Gospel. Behind him is the figure of Peter, holding the golden key to the gate of heaven. On the other panel, standing at the back, is the Evangelist Mark, with a scroll. On the far right is Paul, holding a closed Bible and leaning on the sword – a reference to his subsequent execution.

At the bottom of the two panels are lengthy Biblical inscriptions, selected by Dürer and copied by the calligrapher Johann Neudörffer. These begin with a warning against the dangers of false prophets: 'All worldly rulers in this threatening time, beware not to take human delusion for the Word of God. For God wishes nothing added to his Word, nor taken from it. Take heed of the admonition of these four excellent men, Peter, John, Paul and Mark.' There then follow German texts from the four men, taken from Luther's translation of 1522. Dürer's inscriptions mark his belief in the Reformation, but he expresses concern about the dangers of religious fanaticism.

Although some scholars had believed that the two figures at the back of the pictures, Peter and Mark, had been added later by Dürer, a technical analysis in the 1960s showed that the paintings had originally been conceived with the four men. This examination also confirmed that they were made as a pair, not as wings of a triptych.

Neudörffer himself later claimed that the holy men depicted by Dürer represented the four temperaments. John, young and dressed in red, was sanguine. The aged Peter, his face wrinkled and eyes lowered, was phlegmatic. Mark, in the prime of his life and gazing upwards, was choleric. Paul, with his severe and worried face, was melancholic.

In 1627, after *The Four Holy Men* had been in the city hall for a century, the Bavarian Duke Maximilian ordered the panels to be taken to Munich for his art collection. Nuremberg officials hoped that the Catholic duke would object to the inscriptions and return the panels. But instead he simply had the offending inscriptions sawn off the originals. *The Four Holy Men* was kept in Munich and only the inscriptions were returned to Nuremberg. It was not until the 1922 that Dürer's inscriptions were finally reunited with the two panels, which remain in Munich.

These are Dürer's last known oil paintings, done when he was 55. They represent his spiritual testimony and are among his most powerful works.

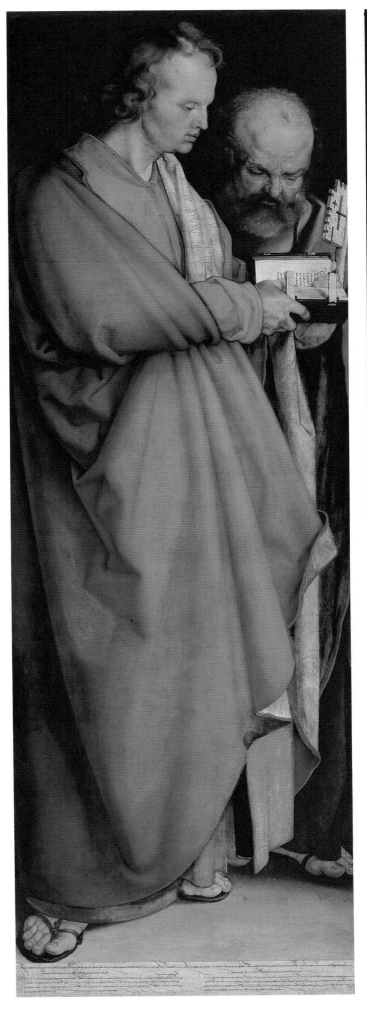
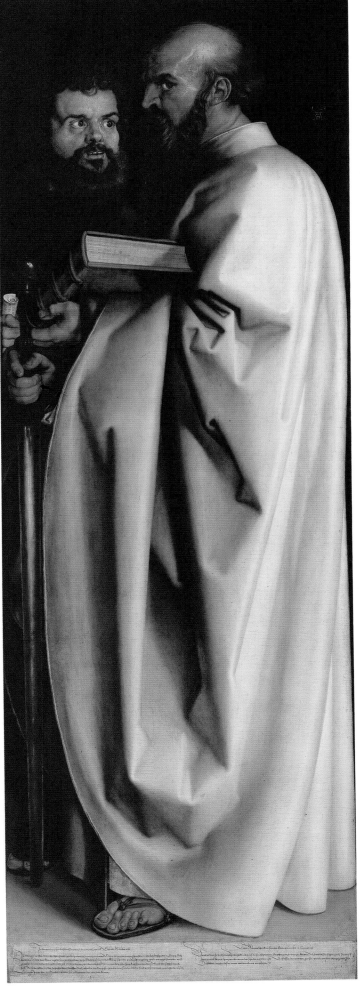

PHAIDON COLOUR LIBRARY
Titles in the series

FRA ANGELICO
Christopher Lloyd

BONNARD
Julian Bell

BRUEGEL
Keith Roberts

CANALETTO
Christopher Baker

CARAVAGGIO
Timothy Wilson-Smith

CEZANNE
Catherine Dean

CHAGALL
Gill Polonsky

CHARDIN
Gabriel Naughton

CONSTABLE
John Sunderland

CUBISM
Philip Cooper

DALÍ
Christopher Masters

DEGAS
Keith Roberts

DÜRER
Martin Bailey

DUTCH PAINTING
Christopher Brown

ERNST
Ian Turpin

GAINSBOROUGH
Nicola Kalinsky

GAUGUIN
Alan Bowness

GOYA
Enriqueta Harris

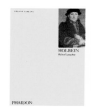

HOLBEIN
Helen Langdon

IMPRESSIONISM
Mark Powell-Jones

ITALIAN RENAISSANCE PAINTING
Sara Elliott

JAPANESE COLOUR PRINTS
J. Hillier

KLEE
Douglas Hall

KLIMT
Catherine Dean

MAGRITTE
Richard Calvocoressi

MANET
John Richardson

MATISSE
Nicholas Watkins

MODIGLIANI
Douglas Hall

MONET
John House

MUNCH
John Boulton Smith

PICASSO
Roland Penrose

PISSARRO
Christopher Lloyd

POP ART
Jamie James

THE PRE-RAPHAELITES
Andrea Rose

REMBRANDT
Michael Kitson

RENOIR
William Gaunt

ROSSETTI
David Rodgers

SCHIELE
Christopher Short

SISLEY
Richard Shone

SURREALIST PAINTING
Simon Wilson

TOULOUSE-LAUTREC
Edward Lucie-Smith

TURNER
William Gaunt

VAN GOGH
Wilhelm Uhde

VERMEER
Martin Bailey

WHISTLER
Frances Spalding